RENAISSANCE AND BAROQUE

DATE DUE

JAN 2 4 1989		
SEP 0 9 1993 F		
DEC 0 2 1996		
FEB 1 3 02 APR 0 3 02		
JUN 1 3 02		
JUN 0 2 03 NOV 0 3 04		
DEC 0 3 04 DEC 0 3 04		
MAR 0 9 05		
SEP 2 6 06		

DEMCO 38-297

RENAISSANCE
and BAROQUE

BY HEINRICH WÖLFFLIN

Translated by Kathrin Simon
With an Introduction by Peter Murray

Cornell Paperbacks
CORNELL UNIVERSITY PRESS
ITHACA, NEW YORK

First published by Benno Schwabe & Co., Verlag, 1961
First published in the Fontana Library, 1964
First published in the United States of America
by Cornell University Press, 1966
First printing, Cornell Paperbacks, 1967
Fourth printing 1984

International Standard Book Number 0-8014-9046-4
Library of Congress Catalog Card Number 65-22724
Printed in the United States of America

CONTENTS

ILLUSTRATIONS

TEXT FIGURES

The subject of this study is the disintegration of the Renaissance. It is intended to be a contribution to the history of style rather than of individual artists. My aim was to investigate the symptoms of decay and perhaps to discover in the 'capriciousness and the return to chaos' a law which would vouchsafe one an insight into the intimate workings of art. This, I confess, is to me the real aim of art history.

The transition from Renaissance to Baroque constitutes one of the most interesting chapters in the story of the art of more recent times. I trust that I do not need to justify myself in advance for having dared to conceive this transition in psychological terms, but I ask the reader to be forbearing in his judgment. This work is in every way an experiment, and I beg him to regard it as such.

At the last moment I dropped my original plan to include a parallel study of baroque in ancient art, because it would have made the book too weighty; but I hope however to pursue this curious parallel on some other occasion.

Heinrich Wölfflin

TRANSLATOR'S PREFACE

This translation has been made from the first edition of *Renaissance und Barock*, which appeared in 1888. The expanded editions of 1906, 1908, and 1924 were produced with Wölfflin's permission, but not under his supervision.

Parts of *Renaissance und Barock* are written in the abbreviated style of lecture notes, with examples attached inside brackets. I have tried to assimilate the tone of these passages to that of the rest of the book to the extent of sometimes adding articles and verbs. The italics correspond to double-spaced phrases and headings in the original.

I am indebted to Dr. Peter Murray for his generous help with selecting and obtaining the illustrations to this book and also to Dr. Michael Podro, who checked most of the translation sentence by sentence. Without his patience and his knowledge of the intellectual background to Wölfflin's ideas and terminology this translation would hardly have been completed. Errors and omissions remain the translator's.

Kathrin Simon

INTRODUCTION by PETER MURRAY

Heinrich Wölfflin was born at Winterthur in Switzerland in 1864 of a wealthy Basle family. Although it is now exactly a century since he was born, he died comparatively recently, on the 19th July, 1945; but, although he is often regarded as one of the founders of modern art history, in other ways he was a great nineteenth century figure almost as distant from us as is Ruskin. In fact, it is possible to maintain that Wölfflin's best work was done in Ruskin's lifetime. Ruskin died in 1900 and Wölfflin's first two major books were published in 1888 and 1899. This somewhat surprising contrast is due, of course, to the fact that Wölfflin was eighty-one when he died and that his first book, *Renaissance and Baroque*, was published when he was only twenty-four. By best work I mean *Renaissance and Baroque* and *Classic Art*, although many people would regard the *Principles of Art History*, published in 1915, as the fullest statement of Wölfflin's ideas. This is probably true; but it is at least arguable that the earlier books are both more sensitive and more sensible.

Little is known about Wölfflin's private life nor does it seem to be particularly relevant. He had, it is true, a certain complacency which probably arose from the fact that he was wealthy all his life and was also successful both as a teacher and a writer. However this may be, his great sensibility to works of art remained his strongest point and one which is evident in his writings and always when he is describing actual works of art. The most important fact in his early life and training was undoubtedly his good fortune in living in Basle when Jacob Burckhardt was still alive and

teaching. Burchkhardt's *Civilisation of the Italian Renaissance*, one of the great books of the nineteenth century, was first published in 1860. Although it was far from successful in its first edition, 15,000 copies were sold before 1890 and since then it must have sold something like a million. Burckhardt's other major book, *The Cicerone*, is a guidebook which is also a complete history of Italian art. *The Cicerone* has been the principal guidebook to Italy for many generations of German-speaking students, so that when Wölfflin came to succeed Burckhardt in the Chair of Art History at Basle in 1893, when he was less than thirty, Wölfflin could hardly help being regarded – and regarding himself – as continuing Burckhardt's work. This is confirmed by the fact that Burckhardt suggested to Wölfflin the outline of what was to become his theory of vision. Burckhardt said: 'As a whole the connection of art with general culture is only to be understood loosely and lightly. Art has its own life and history'* and it was this conception of the arts as something existing in their own right which Burckhardt never really worked out but which is the basis of Wölfflin's theories. Both men were profoundly influenced by Hegelian philosophy, as indeed every learned German has been until comparatively recently, but it was Wölfflin who set himself to formulate a consistent theory of art. Probably the actual formulation is less important than the steps which led up to it, and it is more than probable that Wölfflin succeeded best in his acute analyses of individual works of art, and least where he tried to draw philospohical conclusions from the results.

Wölfflin's career was highly successful. He very soon moved from Basle to the Chair at Berlin then, as now, the crowning point of any German professorial career. From Berlin he exercised an immense influence, since his lectures

* Unpublished lecture notes, quoted by Wölfflin, *Gedanken zur Kunstgeschichte*, 1941, p. 24. Wölfflin admits that this appears to contradict most of Burckhardt's work.

were attended by huge crowds and, at the same time, a whole generation came to Berlin to work on doctorate theses under him. So great in fact was his success that he retired from the Chair at Berlin and transferred to Munich, where he had studied as a young man. His influence was not confined to the German-speaking countries; both Britain and America were deeply affected by his teachings, which came at the moment when art history was just beginning to find its feet in both countries. The first translation of one of his books into English was made in 1903 and was greeted in an enthusiastic review by Roger Fry. This was *Classic Art*, which is still in use as a university textbook. In Italy his ideas were attacked by Croce and others, but his importance is again attested by the early translations of his books.

His main works are *Renaissance und Barock* (1888); *Die klassische Kunst* (1899); *Kunstgeschichtliche Grundbegriffe* (1915) and *Italien und das deutsche Formgefühl* (1931) and it is a curious fact that *Renaissance and Baroque* is now being published in English for the first time in this admirable translation, although the others have all been available for some years past. In addition to these books he wrote a number of specialised articles and several other books including monographs on Dürer and Michelangelo. He also wrote, in 1921, a short essay called *Das Erklären von Kunstwerken*, to which he added an appendix in 1940. This brief essay has never been translated into English but it poses most of the questions asked at much greater length in the bigger books, and in the appendix of 1940 it shows some evidence of a revision of his philosophical position as a result of the cogent criticisms directed against his *Principles of Art History* on its publication in 1915. This appendix contains the sentence: 'The art of the Italian Renaissance, in its subject matter and its conception of beauty, is a clear expression of a fixed, autonomous, way of looking at the world; but the next stage, the Baroque, is incomprehensible without the spirit of the Counter-

Reformation.' To a modern reader this remark appears platitudinous, but it is in fact the negation of much that Wölfflin had written in his earlier books. It is the justification and the recognition of what we may perhaps call 'modern' art history. The sentence itself is typical of one aspect of Wölfflin – 'the Renaissance' is personified since 'it' has a conception of beauty – and this kind of sentence is not uncommon in Wölfflin's works which are apt to contain grandiose imponderables not easily rendered in a concrete language like English. The present book affords some examples of this but the tendency became much more marked in Wölfflin's later works, and one of the reasons for producing an English translation of *Renaissance and Baroque* three-quarters of a century after its original appearance is because it contains a larger proportion of acute visual analysis and a smaller proportion of generalisation than the later works. The sentence quoted above seems to distinguish between the art of the Renaissance, which is autonomous, and the art of the Baroque, which is conditioned by the Counter-Reformation. This idea of two types of art, one conditioned by non-aesthetic factors and the other not so conditioned represents a modification of Wölfflin's original ideas. In his *Principles* and elsewhere he advances (or rather assumes) the concept of an autonomous Renaissance; of a style, in other words, which is an entity existing in its own right and independent of actual works of art. Normally, one thinks of a style as an abstraction deduced from the specific characteristics of a number of works of art; but to Wölfflin it is independent of them. This is a Hegelian idea, the idea of a Demiurge expressing itself in a Will-to-Form using the artist as a mere instrument. This has been well summed up by Professor Ettlinger: 'As far as the treatment of art history is concerned, from the curious alliance of Winckelmann, the Romantic antiquarian, and Hegel, the determinist philosopher of history, was born that preoccupation with the general

problem of "styles" – both national and period – which has been so pronounced a characteristic of art historical studies right up to our own day. The individual work of art and all its qualities became submerged in something larger. Instead of being apprehended as the result of a concrete task and a personal creative act, it became the expression of an inescapable super-individual force.'* Wölfflin sought a different kind of art history from that which is typical of the mid-twentieth century. We have come to realise that we possess a pitifully small stock of facts and documents, and we have learned that the broad generalisation can be all too easily upset by a handful of innocuous-seeming facts. Burckhardt's conception of the Renaissance, like that of John Addington Symonds, is now very distant and seems rapidly to be receding still further. Wölfflin, however, was not really interested in facts and documents, since he claimed to seek an art history without names. It might well be argued that this is simply the Pathetic Fallacy in another form, imputing human motives and emotions to inanimate things, since it involves the personification of style, which is then endowed with its own laws of growth. Against this it may be claimed that style is simply a Platonic Idea and that it is possible to think of The Baroque as the style of Bernini but not possible to think of Bernini as the incarnation of Baroque in any but a metaphorical sense. Bernini – least of all artists – was not a helpless tool manipulated by The Baroque Spirit. To say, as Wölfflin says, that the Baroque 'does' this and the Renaissance 'does' that, is, in the last resort, sheer anthropomorphism. When Wölfflin writes: 'In the Dutch style of the seventeenth century it was the free a-tectonic† style which existed for Ruysdael as the only possible form of presentment'

* L. D. Ettlinger, *Art History Today, an Inaugural Lecture delivered at University College, London,* 1961, p. 10.

† By 'a-tectonic' Wölfflin means a style which is not based on a balance of masses subordinated to a rigid geometry of horizontals and uprights such as one finds in architecture.

he is being quasi-determinist as well. Nevertheless, these rigorous philosophical systems have their uses. What Wölfflin really meant in the sentence just quoted could probably be put much more simply (and more truthfully) by saying that, by the seventeenth century, the technique of oil painting had been developed to a pitch which made it virtually unthinkable to employ the forms which came naturally to an earlier generation. This is much less determinist; but it is perhaps arguable that in the late nineteenth century some such attitude was essential as an antidote to the English conception of art history which, at its worst, amounted to the belief that a day-by-day chronicle of the activities of an artist is the same thing as an art historical monograph. The idea underlying this goes still further back to the great German historian Ranke whose battle-cry was the idea that it is possible to discover what actually happened – *wie es eigentlich gewesen* – and, as a result of this, that if we know exactly *what* happened we shall know *why*. From the point of view of art history, this is the attitude which lies behind one of the greatest of nineteenth century books *A New History of Painting in Italy* by J. A. Crowe and G. B. Cavalcaselle, published in London in 1864–66. Crowe and Cavalcaselle were concerned above all with establishing whether or not a given artist painted a given picture, and to do this they made use of documentary criticism, as well as the study of the work itself, in a way which is the foundation of the so-called science of connoisseurship. The contrast between this and Wölfflin is obvious; and it is also obvious that Wölfflin's method, which claims to reveal the inner meaning of a picture, is both more exciting and more dangerous. In fact, Wölfflin concentrates exclusively upon general stylistic characteristics and avoids the detailed morphological approach of Crowe and Cavalcaselle. Both completely neglect the problem of iconography – the problem of discovering what the artist intended to represent as distinct

from a description of what is actually present in the picture. This neglect of iconography is not really important for Crowe and Cavalcaselle, since they do not claim to reveal the inner meaning of a picture; but when Wölfflin neglects iconography it can vitiate his whole approach. This is particularly the case where he discusses works like Bernini's *S. Teresa*, generally regarded as a key-work of the Baroque style in Rome. In this, and in the similar statue of the Blessed Ludovica degli Albertoni, Bernini is evidently attempting to render something quite transcendental and something which had never been attempted by a sculptor before this date. Indeed, it is possible to argue that S. Teresa's mystical ecstasies are themselves something entirely new in the spiritual life of Europe. Some quotations from contemporary writers show quite clearly that the imagery of the Song of Songs came naturally to mind and that these ecstasies, in so far as they are communicable at all, can only be expressed in terms normally used of physical passion:

> *Live in these conquering leaves; live all the same;*
> *And walk through all tongues one triumphant flame;*
> *Live here, great heart; and love, and die, and kill;*
> *And bleed, and wound, and yield, and conquer still.*
> *Let this immortal life where'er it comes*
> *Walk in a crowd of loves and martyrdoms . . .*
> *O sweet incendiary! show here thy art*
> *Upon this carcase of a hard, cold heart . . .*

(*Upon the Book and Picture of the Seraphical Saint Teresa*, Richard Crashaw)

> *Plaga ludibunda saevit: fax perurit viscera.*
> *Ergo vitae sicca tendit ad perennis flumina;*
> *Sed citata, fonte viso quem requirit, occubat.*
> *Nunc amet quae non amavit; quaeque amavit nunc amet.**

(From the *Festal Song of the Divine Love bearing the Triumphant Soul to the Heavenly Spouse*, by Jacob Balde, s.j., who died in 1668.)

* *The welcome wound burns, the flaming torch consumes her inwardly.*
 Thus thirsting she seeks the river of eternal life
 And, urged onwards, lies prostrate by the Fountain she seeks.
 May she know love who is yet a stranger to it: and may she who has loved love on.

7

or in the words of S. Teresa herself: 'God willed that I should see, at my left side, an angel in bodily form . . . He was not very big, but very beautiful; his resplendent face indicated that he belonged to that Order of the celestial hierarchy known as Seraphim, whose faces seem to burn with fire – I have noticed that, when angels appeared to me, they were not always the same, but it is difficult to express the differences in words. He held a long javelin of gold, with an iron tip which had a flame coming out of it. Suddenly, he pierced me to the inmost fibre of my being with it and it seemed to me that, as he drew it out, he dragged me with it; but I felt entirely consumed by the love of God. The pain was so great that it drew moans from me, even though the ecstasy which went with it was so great that I would not have had the pain withdrawn – for this ecstasy was God himself. This suffering was not bodily but spiritual, even though the body was involved in it . . .'*

It is clear that these writers and Bernini were all trying to do something very difficult and very complex with overtones that are not particularly easy for us to catch, but which they obviously expected their contemporaries to understand; and these attempts to create equivalents for a psychological state are, fundamentally, the essential which the artists are trying to communicate. Wölfflin himself describes the Bernini statues at some length but at no point does he ever mention the subject. For this reason it is legitimate to criticise him by saying that what he was trying to do bore very little relation to the artist's own primary intention; that, in fact, Wölfflin was trying to isolate a visual denominator which, he claimed, was common to all works produced at the same time. This is why his method of analysis is at its best when he is dealing with architecture. There is such a thing as iconography in architecture and it is far more important than is sometimes realised, but it must

* Cf. *Acta Sanctorum*, October, vii, p. 239.

necessarily be much less specific than in those forms of paint-
ing and sculpture which are basically representational.

The first sentence of *Renaissance and Baroque* reads thus: 'It
has become customary to use the term *baroque* to describe
the style into which the Renaissance resolved itself or, as it is
more commonly expressed, into which the Renaissance
degenerated.' Nowadays, we would describe the same
phenomenon by the word 'Mannerism' and it has been
argued that, because Wölfflin was apparently unable to dis-
tinguish as precisely as we claim to be able to do between
Mannerism and Baroque, that therefore his whole picture
of Baroque art is fundamentally wrong. This, I think, is
unfair because we are simply disagreeing over terminology.
Wölfflin clearly meant the phenomenon which we call
Mannerism even though he calls it Baroque, because he
goes on to say that the problem is to analyse what happened
to the Renaissance and what happened between about 1520
and 1630. He also says that the year 1580 conveniently
marks the fully-formed Baroque. We nowadays would ac-
cept the year 1580 as a watershed, but we would tend to
regard it as the end of the Mannerist period and to date the
beginning of the Baroque style from about 1600; and it is
necessary, therefore, to discuss why Wölfflin's conception
of the essential unity of Baroque art has been abandoned.
A quotation will help to explain why Wölfflin's conception
of Baroque has been expanded. He definies it thus: 'It is
generally agreed among historians of art that the essential
characteristic of baroque architecture is its painterly qual-
ity. Instead of following its own nature, architecture strove
after effects which really belong to a different art-form.... If
the beauty of a building is judged by the enticing effects of
moving masses, the restless, jumping forms or violently
swaying ones which seem constantly on the point of change,
and not by balance and solidity of structure, then the

strictly architectonic conception of architecture is depreciated. In short, the severe style of architecture makes its effect by what it *is*, . . . while painterly architecture acts through what it *appears* to be, that is, an illusion of movement'.* These polarities can easily be found at the beginning and the end of the period, the balanced and static in the work of Bramante and his immediate followers and the moving masses in the work of Borromini; but the key to the whole development of the conception of Mannerism lies in the very fact that around 1580 it is possible to find important buildings, such as the Gesù in Rome, which are neither static nor dynamic. The description given by Wölfflin of the Gesù is therefore of great importance. He begins† by defining the Gesù as Vignola's typical Baroque building, and he then makes an important contrast between the façade designed by Vignola himself and the one which was actually built by Giacomo della Porta after Vignola's death in 1573. He sees very acutely that there is a considerable difference between the two in spite of the fact that both consist of the same architectural elements; and he sees also that Vignola, by comparison with Giacomo della Porta, achieves an effect which is almost Renaissance in feeling. He then goes on to define the differences very closely, saying that the division of the bays by Vignola is such that each element retains a certain amount of independence, whereas della Porta creates a massive effect by breaking down the separating divisions between pilasters, niches and string courses. What is more, Wölfflin continues, 'With Maderna a progressive force appears again. Maderna began where Giacomo della Porta had left off, and then went his own independent way. . . . His first independent creation was the façade of S. Susanna (pl. 6), and it remained his best. . . . The façade is graduated in three stages from the centre

* See below, p. 30
† See below, p. 91.

outwards, in terms of a plasticity that progresses from columns to half-columns, and from half-columns to pilasters. The outer bays are not left empty: the decoration, setting out from the two superimposed tablets, progresses to a sumptuous overflowing richness in the centre bay. Niches with their statues, pediments, garlands are all richer and more animated than before. The profusion of the decoration diminishes as the building rises: the upward movement is strongly emphasised and only plays itself out in the regular decoration of the tympanum. But, in contrast to Della Porta, Maderna already showed that artistic severity was beginning to soften; the pressure seemed to be lifting, and the dominance of the horizontal was broken.'

It would nowadays be generally agreed that this contrast is correct and that it is the façade of Sta Susanna, completed in 1603, which can be taken as the first typical Baroque work. To put it another way, modern art historians accept Wölfflin's contrast between the Gesù and Sta Susanna while insisting that two separate styles are typified by the two churches and not merely two subdivisions of a single style. In this connection the most important word is probably 'pressure' since the present conception of Mannerism is that of a style subject to extreme internal tensions which finally disrupted it, and the idea of Baroque art is that of a new synthesis which subsumed the elements of Mannerism.* In fact, Wölfflin himself foresaw much of this, since his analysis of Michelangelo's architecture necessarily included the idea of tension, and he goes so far as to say that the sense of struggle which is so marked in Michelangelo's Laurenziana is specifically Baroque.†

At this point we must disagree, for the tension which is characteristic of Mannerism is also peculiar to it: Baroque

* This emphasis on tension may be connected with the enthusiasm for – or 'discovery' of – Mannerist art in post-war periods, e.g. the 1920's and 1940's.

† See below, pp. 60-61.

is, by definition, a new synthesis and a new equilibrium basically similar to the classical style in its unified effect. Compare the façades (pl. 5 and 6) of S. Susanna and the Gesù once more, and it will be seen that the progression of the eye, in S. Susanna, is made easy by the outer bay consisting of one pilaster, two small decorative fields, and then a marked break forward to the next bay; which has a half-column and a break forward in the entablature, followed by a large niche with an over life-size statue leading the eye once more in towards the centre; and, finally, the centre itself has two half-columns and another clear break forward in the entablature, this time emphasised by the triangular pediment. In the Gesù the elements are far more complicated in their disposition: the outer bay has a pair of pilasters and then a break forward in the entablature above two-and-a-bit pilasters, with the break forward in the entablature at once cancelled and retreating to the level of the outer bay. The side doors have statues over them, very like those at S. Susanna, but the placing is such that one is never certain whether the door or the statue is the more important thing. Finally, the centre itself has a profusion of pediments above the single pilaster and half-column, each of which is supposed to carry one of the pediments. These differences can be shown to be true of practically every Roman building on either side of the year 1600, and indeed it is possible to distinguish several subdivisions both of Mannerism and of Baroque. That we can do so is due in very large measure to Wölfflin's pioneer work, of which this book is not the least important.

Peter Murray

RENAISSANCE AND BAROQUE

*An investigation into the nature and origin
of the Baroque Style in Italy*

by HEINRICH WÖLFFLIN

INTRODUCTION

It has become customary to use the term *baroque* to describe the style into which the Renaissance resolved itself or, as it is more commonly expressed, into which the Renaissance degenerated. For Italian art this stylistic change has a significance radically different from that which it has for northern art. In Italy we find an interesting progression from a strict to a 'free and painterly' style, from the formed to the formless, a development in which the northern peoples did not participate; with them the architecture of the Renaissance was never subjected to the pure and ordered articulating process that it underwent in the south, but was always more or less open to the capricious influence of the painterly or even the decorative. In the case of northern art we cannot, therefore, speak of the 'dissolution' of a formal style.

The history of ancient art, on the other hand, does provide a comparable phase, and for this too the term 'baroque' is gradually coming into use. Ancient art 'dies' from symptoms analogous to those with which the Renaissance ended. It is these symptoms we must try to diagnose.

To do so we will begin by limiting our field of inquiry. First of all there is no such thing as a general Italian baroque style; the Renaissance style underwent different transformations in different parts of the country and for three reasons Roman baroque alone has a right to be regarded as, so to speak, the typical manifestation.

In the first place, it was in Rome that the Renaissance style found its most lucid expression. Bramante's style is at his purest there, the ancient ruins sharpened architectural awareness in such a way that it is in Rome that the relaxation of formal rules is felt more keenly than elsewhere. The

15

laws we regard as valid for Italian architecture as a whole held doubly good there, and we must follow the course of the baroque where strict form was most acutely felt and where, consequently, its dissolution is most consciously carried through. Nowhere is there a greater contrast between the two.

In the second place, the baroque appeared earlier in Rome than anywhere else. It is not a matter here of inferior artists following in the steps of genius; the baroque was introduced by the great Renaissance masters themselves, emerging at the height of the Renaissance. Rome remained always in the vanguard of artistic development.

It was, finally, Roman baroque that represented the most complete metamorphosis of the Renaissance. Elsewhere the old style remained more or less recognisable, the new being often no more than an exaggerated version of the old, but in Rome no trace of the earlier style remained. The so-called Venetian baroque, at the opposite pole from its Roman counterpart, contained nothing new at all. So it is that Jacob Burckhardt describes it as 'the pettiest ideas of the early Venetian Renaissance strutting disguised in baroque garb.'[1] Indeed we might not be far wrong in speaking of baroque as a purely Roman thing.

We have described the geographical boundaries of baroque, and we must define it more closely in time. It is bounded at one end by the Renaissance, and at the other by the new classicism which began to emerge in the second half of the eighteenth century; it lasted in all some two hundred years. Inside this period, however, baroque changed so much that it is difficult to think of it as a single whole. Beginning and end have little resemblance to each other and it is difficult to distinguish any continuity. Burckhardt has already observed that in any historical survey of the period a new sub-section should begin, about the year 1630, with Bernini. The early baroque style is heavy, massive, restrained

and solemn. This pressure then gradually begins to lift and the style becomes lighter and gayer; it concludes with the playful dissolution of all structural elements which we call *rococo*.

The aim of this book is not to describe the whole course of this development but to clarify its origins. What, in other words, became of the Renaissance? We are therefore concerned only with the period prior to 1630. This period follows immediately on the High Renaissance, for there is no such thing as a 'late Renaissance period' in Rome; there are only belated Renaissance artists, for whom we can hardly institute a special stylistic phase. The High Renaissance does not pass over into a clearly defined late period; the climax leads directly into the baroque, and where something new appears, it is a symptom of the coming baroque style.

One can only justify a statement like this by making a formal analysis of the complex of symptoms that constitutes the baroque; only when we have made this analysis will we know where the baroque begins. We must always begin, however, with that group of works which an admiring posterity has long regarded as the creation of a Golden Age. The climax of this golden age is short, for it is fair to say that after 1520 not one really pure work was produced. The heralds of the new style approach, increase in number, and finally gain the upper hand, dragging the whole edifice with them: baroque has come into being. There can be no objection to taking the year 1580 as a convenient starting-point for the fully-formed baroque style.

The Principal Architects

It is not the business of the historian of style to give a detailed account of the whole treasury of artistic creativity or to treat in detail of the work of individuals. He is concerned only with the great, the truly style-creating geniuses, and for

biographical details he may simply refer the reader to the appropriate literature.[2]

The most important figures are Antonio da Sangallo, Michelangelo, Vignola, Giacomo della Porta and Maderna; the late works of Bramante, Raphael and Peruzzi prepare the way.

Bramante had been in Rome since the end of 1499, and his style underwent a significant development there. His 'ultima maniera' was first distinguished by Heinrich von Geymüller. Although the Cancelleria (p. 12), the church of S. Pietro in Montorio and the Vatican palace may seem the perfect expression of the pure Renaissance style, these buildings alone are not representative of Bramante's Roman manner. The last phase of this style is heavy and grand, as is revealed in the so-called house of Raphael, recorded only in a drawing by Palladio,[3] and by the Palazzo di S. Biagio, a building that was hardly more than begun.

In ecclesiastical architecture, the most important undertaking, and the one in which the finest talents of the time were tested, was the rebuilding of St. Peter's. Each of Bramante's various designs formed a different stage of stylistic development. One might almost restrict this account to the history of this building, for it bears the marks of every stylistic phase from Bramante's first plan to Maderna's nave.

Raphael's significance as an architect, as Geymüller has pointed out, is that he both continued the late manner of Bramante and mediated between Bramante and Palladio. The Palazzo Vidoni-Caffarelli is the immediate sequel to Bramante's House of Raphael (fig. 27). The Palazzo dell' Aquila, however, which is recorded only in drawings and engravings, reflects a new spirit, and was influential for the later development of the palace façade (fig. 25).[4] Raphael also produced a longitudinal design for S. Peter's.

The last works of *Baldassare Peruzzi*, the Palazzo Costa

and the Palazzo Massimi alle Collone, prefigured the new conception of form.

One of the chief agents in the evolution of the baroque style was *Antonio da Sangallo* the Younger. His style is massive and severe, 'robusto e severo'. He learnt much from Raphael but developed what he learnt along quite independent lines, and many of the new models are of his invention. His masterpiece is the Palazzo Farnese (pl. 13),[5] while his own house, now the Palazzo Sacchetti (pl. 14), became the model of the aristocratic town residence.

Michelangelo has always been recognised as the 'father of baroque'. There is perhaps some significance in the fact that he only began his architectural activity in his maturity, when he already had a reputation which guaranteed him admiration and imitators for everything he did. From the first Michelangelo treats his forms with sovereign inconsiderateness, purely as elements in a composition of plastic contrasts and overall effects of light and shade, with no thought for their structural purpose. Every line is significant. His Florentine works are the projects of 1516 and 1517 for the façade of S. Lorenzo, the new sacristy or mortuary chapel of the Medici in the same church, begun in 1520, and the Biblioteca Laurenziana, begun about 1523 (the staircase is later) (pls. 1 and 2).[6]

In Rome, his project for the rebuilding of the Capitol dates from the first years of Paul III's pontificate. The inscription gives the year 1538 for the re-erection of the statue of Marcus Aurelius, whose oval pedestal was designed perhaps already with a view to an oval piazza. The double staircase in front of the Palazzo de' Senatori must date at the very least from the period before 1555;[7] the building itself was finished only by Giacomo della Porta and Rainaldi. When Vasari wrote the second edition of his *Lives* the Palazzo dei Conservatori was probably complete in all

essentials. The corresponding palace on the other side of the piazza is however of later date. The gently ascending staircase to the piazza, the *Cordonnata*, Vasari mentions as unfinished.[8]

On January 1st 1547, the destinies of St. Peter's were placed in Michelangelo's hands and he directed the building operations until his death. His plan, his elevation of the exterior of the apse and model for the cupola (1558) all form stages of the most vital importance for the new style. The work of his last years is the church of S. Maria degli Angeli, transformed from the main hall of the Baths of Diocletian, and the Porta Pia of 1561.

Michelangelo determined the entire development of architecture subsequent to his death. No one who had once entered his orbit could resist its spell, yet no one dared to imitate him outright. In the period before Bernini the leading spirits were Vignola, Giacomo della Porta and Maderna.

Jacopo Barozzi da Vignola (1507–73) came from the region of Modena. He is generally thought of as the supreme exponent of rule and because he is the author of a famous treatise on the five orders he is thought of primarily as a theorist, the representative of academic orthodoxy. But this view is unjust; a glance at the title-page of his *Regola* is enough to convince us that Vignola not only took great liberties but permitted them in others. For capriciousness of form the courtyard of the Palazzo de Firenze competes with Michelangelo's Laurenziana.

Vignola's rise to prominence began with his second visit to Rome in 1550 as a man of 43, during the pontificate of Julius III.[9] A first stay in his youth had given him a classical training; now he entered the spiritual sphere of Michelangelo. The little church of S. Andrea in Via Flaminia is still restrained and severe and the Villa Giulia, timid and experimental, must, it seems, be attributed in the main not to

Vignola at all, but to a series of masters including possibly Michelangelo, Ammannati, Vasari and the patron, Julius III.[10]

Michelangelo must have had a high opinion of Vignola, for he used him to build the *galleria* and many details such as doors and windows in the Palazzo Farnese and put him in charge of building operations on the Capitol, where he also executed the porticoes facing S. Maria Araceli and the Monte Caprino.[11] On Michelangelo's death he became chief architect of S. Peter's and built the subsidiary domes, which show a characteristic advance on Michelangelo's style. His masterpieces, however, are the Villa Farnese at Caprarola, a huge pentagon erected for the Farnese in the transitional style of the 1550's (pl. 18), and the church of the Gesù in Rome which was begun in 1568 and became the prototype of all baroque churches (pl. 5).[12] Death prevented him from completing it, but his project for the façade is preserved in an engraving (fig. 15).[13]

Vignola's successor in the Gesù and in Roman architecture in general was *Giacomo della Porta*. Giacomo was not the brother of the sculptor Gulielmo della Porta as is usually suggested, nor even a Lombard, but, in Baglione's words, 'di patria e di virtù' Romano'.[14] He is generally thought to have been born in 1541, but if, as the inscription states, he had already completed the façade of S. Caterina de' Funari by 1564 (pl. 3), this seems improbably late.[15] Giacomo was widely influential and a favourite of the patrons. The palace façade, the church façade and the villa all owe their specifically baroque character to him. If one could attribute to him its design as well as the actual execution, his greatest achievement would have been the giant dome of St. Peter's.

What della Porta had begun, *Carlo Maderna* completed, exaggerated and, one might well say, destroyed. In his later works Maderna already represents that dissolution of the seriousness that had previously been inherent in baroque.

The will to create something of substance and importance makes way for a more superficial sensibility that aims at no more than a lavish display of decoration. Maderna had shown his ability in the superb façade of S. Susanna, completed in 1603, but his first work remained his best (pl. 6). Apart from the porch, the larger façade of St. Peter's (pl. 7), completed in 1612, did not reach this standard, though it is only fair to remember that the articulation of such a huge surface was an enormous task and that he had to work within the limits already laid down by Michelangelo.

Grouped around these great figures were many lesser ones. There is the capable *Bartolommeo Ammannati*, a Florentine and contemporary of Vignola, who took to architecture only in Rome, comparatively late in life, and absorbed the Roman idiom in a very pure form. The magnificent Ponte della Trinità in Florence is hardly conceivable without his Roman training, but the palaces he built there soon reverted to the old Florentine tradition. On a second visit to Rome he built the Collegio Romano, a work of very doubtful effect, which shows, particularly in the façade, to what extent the feeling for the grand style had deserted him.

Others were *Martino Lunghi* and his son *Onorio* (*d.* 1619), *Domenico Fontana*, Maderna's uncle (*d.* 1607), and his brother *Giovanni* (*d.* 1614), *Flaminio Ponzio, Ottaviano Mascherino, Francesco da Volterra, Giovanni Fiamingo*, called *Vasanzio*, and many more, none of them native Romans. Most of them were Lombards, and many came from the area round the Lake of Como. Mascherino was Bolognese, Francesco da Volterra came from the town of that name, and Vasanzio was a Netherlander whose real name was Hans von Xanten. Few of these artists really found their feet in the new movement; their use of the new formula was usually inhibited, and they could not capture the new spirit as a whole. Certainly the Romans had more native inclination towards the grandeur and the weighty massiveness peculiar to

baroque. It was on these qualities that the work of a Roman like *Giovan Battista Soria* depended. He, although a mediocre artist, was able to present a late but full version of the 'gravitas' of the earlier style.

Unlike the Renaissance, the baroque style is not accompanied by theoretical rules: it developed without models. There appears to have been no sense of breaking fundamentally new ground and as a result the new style did not receive a name. The term 'stilo moderno' embraced equally all that was neither antique nor of the 'stilo tedesco' or gothic style. Nevertheless some new terms were introduced, such as *capriccioso*, *bizzarro*, and *stravagante*,[16] and anything unusual and uncanonical was greeted with approval. The spell of formlessness was beginning to work.

The modern meaning of the term *baroque*, as it is now also used in Italy,[17] is of French origin. Its etymology is uncertain: one theory is that it comes from the logical term *barocco*, with its suggestion of 'absurd', another that its origin is the 'baroque', or rough-shaped pearl. In Diderot's Encyclopaedia the word already appears in a sense similar to ours: 'baroque, adjectif en architecture, est une nuance du bizarre. Il en est, si on veut, le raffinement, où s'il etait possible de le dire, l'abus . . . il en est le superlatif. L'idée du baroque entraîne avec soi celle du ridicule poussée à l'excès. Borromini à donné les plus grands modèles de bizarrerie et Guarini peut passer pour le maître du baroque.' Today we see no distinction between *baroque* and *bizarre*; if anything, the latter is a little stronger. As an art-historical term *baroque* has lost its suggestion of the ridiculous, but in general use it still carries a suggestion of repugnance and abnormality.

As early as Raphael's death enthusiasm for the *antique* was on the wane. It was not that the remains of antiquity

attracted less attention than before; but whereas the Renaissance had contemplated antiquity with childlike wonder and worshipped it with reverence, stopping short only of direct imitation,[18] this attitude gave way to a more detached and didactic approach. A Vitruvian Academy was founded in Rome to undertake the systematic study of the ancient ruins. Vignola was one of its members, and the fruit of his studies was a treatise on the five ancient orders[19] that remained the standard text on the subject for two hundred years. But the spirit in which this work was written is revealed in the prologue, where Vignola says that his aim is to distil a universally acceptable rule by a selective study of approved forms.[20] In anything outside the orders he recognised no rules at all; he was not concerned with the *spirit* of the antique. With Scamozzi[21] the increasing disapproval of the disregarding of antiquity becomes explicit: 'Le cose fatte dagli antichi vengono sprezzate e quasi derise'; and again: 'Sono molti, che non l'istimano molto.'[22]

The general trend was noticeably towards using the antique as 'rule'. While some purposely infringed it, the more anxious spirits sought to compromise and excuse what they could. Thus Lomazzo, in his *Trattato dell' arte*, listed the instances when even the ancients took liberties in order to justify more recent practices.[23]

But Lomazzo was a Milanese and in Michelangelo's circle different ideas were current. The daring and unprecedented innovations of the New Sacristy were hailed by Vasari with a sense of release. 'Gli artifici gli hanno infinito e perpetuo obbligo, avendo egli rotto i lacci e le catene delle cose, che per via d'una strada commune eglino di continuo operavano.'[24]

More and more it was the grandeur, the colossal scale of ancient monuments that aroused admiration, not the beauty of the individual forms.[25] The habit of seeing the divine in every suggestion of antiquity had disappeared.

Perhaps this can be explained partly by a growing sense of pride and self-consciousness, which in that generation could hardly be regarded as a fault. A conviction had taken root that it was possible to measure oneself against the ancients. Even Michelangelo, with his reputation for modesty, said of one of his projects for S. Giovanni dei Fiorentini that it surpassed anything the Romans or Greeks had achieved in their temples. Vasari several times expressed the same sentiment.[26] This self-awareness may also explain the indifference with which Sixtus V allowed the remains of the Septizonium of Severus to be dismantled for its stone.[27] The baroque possessed a sense of self-confidence and of its own infallibility that is not perhaps found in any other style. It is worthwhile examining the nature of this artistic sensibility rather more closely.

Part I

THE NATURE OF THE CHANGE IN STYLE

I. THE PAINTERLY STYLE

It is generally agreed among historians of art that the essential characteristic of baroque architecture is its painterly quality. Instead of following its own nature, architecture strove after effects which really belong to a different art-form: it became 'painterly'.

The term *painterly* is both one of the most important and one of the most ambiguous and indefinite with which art history works. There is not only painterly architecture, but painterly sculpture. The history of painting has a painterly phase, and yet we speak of painterly light effects, painterly disorder, painterly profusion, and so on. Clearly it is impossible to use the word to definite purpose without first clarifying its meaning. What does 'painterly' mean? It would be simple enough to say that painterly is that which lends itself to being painted, that which without addition would serve as a motif for the painter. A strictly classical temple, if it is not in ruins, is not a picturesque object. However impressive it may be as a piece of architecture, it would look monotonous in a picture. An artist painting it on a canvas today would have great difficulty in making it look interesting; in fact he could only succeed with the aid of light and atmospheric effects and a landscape setting, and in the process the architectural element would retreat completely into the background. But a rich baroque building is more animated, and would therefore be an easier subject for a painterly effect. The freedom of line and the interplay of light and shade are satisfying to the painterly taste in direct proportion to the degree to which they transgress the rules of architecture.

29

If the beauty of a building is judged by the enticing effects of moving masses, the restless, jumping forms or violently swaying ones which seem constantly on the point of change, and not by balance and solidity of structure, then the strictly architectonic conception of architecture is depreciated. In short, the severe style of architecture makes its effect by what it *is*, that is, by its corporeal substance, while painterly architecture acts through what it *appears* to be, that is, an illusion of movement. Neither of these extremes, of course, exists in a pure state.

Painterliness is based on an illusion of movement. Why movement is painterly, and why it is communicated through painting rather than another art form can only be answered by examining the special character of the art of painting. Because it has no physical reality painting has to depend on effects of illusion. Its means of creating an illusion of movement are also greater than those of any other art form. This has not always been so; the painterly period, as we saw, was only one phase in the history of painting, and the painterly style was only slowly evolved by discarding a predominantly linear style. In Italy this process reached completion in the High Renaissance, notably in the work of Raphael: in the course of the Vatican Stanze, his style visibly developed from the old to the new, the decisive turning point coming in the Stanza d' Eliodoro.

The new expressive means that were to have such a decisive influence on architecture were various, and we may now try to list the main features of the painterly style. The most direct expression of an artist's intention is the sketch. It represents what appears most vital to him, and reveals him actually in the process of thinking. It may therefore be useful to start by comparing two sketches so that we may establish the clearest distinction between the two manners. To begin with, the medium changes with the style. Where the linear style employs the pen or the silver-point, the

painterly uses charcoal, red chalk or the broad water-colour brush. The earlier style is entirely linear: every object has a sharp unbroken outline and the main expressive element is the contour. The later style works with broad, vague masses, the contours barely indicated; the lines are tentative and repetitive strokes, or do not exist at all. In this style, not only individual figures but the entire composition are made up of areas of light and dark; a single tone serves to hold together whole groups of objects and contrast them with other groups. While the old style was conceived in terms of *line* and its purpose was to express a beautiful and flowing linear harmony, the painterly style thinks only in masses, and its elements are light and shade.

Light and shade contain by nature a very strong element of movement. Unlike the contour, which gives the eye a definite and easily comprehensible direction to follow, a mass of light tends to a movement of dispersal, leading the eye to and fro; it has no bounds, no definite break in continuity, and on all sides it increases and decreases. This, basically, is how the painterly style evokes an illusion of constant change. The contour is quite annihilated, and the continuous, static lines of the old style are replaced by an indistinct and gradually fading boundary area. Where figures had been sharply silhouetted against a light ground, it is now the ground that is usually dark; the edges of the figures merge into it, and only a few illuminated areas stand out.

Corresponding to this distinction between linear and massive is another, that between 'flat' and 'spatial' (substantial). The painterly style, with its chiaroscuro, gives an illusion of physical relief, and the different objects seem to project or recede in space.[1] The expression 'backward and forward' in itself suggests the element of movement inherent in all three-dimensional substances as compared to flat planes. In the painterly style, therefore, all flat areas become rounded and plastic with a view to effects of light and shade.

If the contrast between light and dark is extreme an object may appear to jump right out of the picture plane.

A development of this sort is easily distinguishable in the Vatican Stanze. Raphael appears to have made quite conscious use of this method, which he combined with a new and agitated technique. In the Expulsion of Heliodorus the dramatic force is considerably enhanced by isolated flashing points of light set off against a dark ground.[2] At the same time the picture space becomes deeper. The frame is sometimes seen as a gateway and in the later pictures suggests a real vista seen through an opening. Behind it, instead of a single plane or row of figures, is a deep recession that draws the eye into infinity.

The aim of the painterly style is to create an illusion of movement; its first element is composition in terms of areas of light and shade, its second is what I should call the *dissolution of the regular*, a free style or one of painterly disorder. What is regular is dead, without movement, unpainterly.

Unpainterly are the straight line and the flat surface. When these cannot be avoided, as in the representation of an architectural motif, they are either interrupted by some kind of accidental feature, or the building is depicted in a state of crumbling ruin; an 'accidental' drapery fold or something of the sort must be introduced to enliven it.

Unpainterly are the uniform series and the regular interval; a rhythmic succession is better, and better still is an apparently quite accidental grouping, depending entirely on the precise distribution of the masses of light.

To gain an even greater sense of movement, all or most of the composition is placed obliquely to the beholder. This of course had long been done with individual figures, but previously groups and architecture had always been disposed according to strict rule. A gradual change can be observed in the Stanze, from the books in the *Disputà*, timidly laid on a slant, to the little table in the School of Athens or the

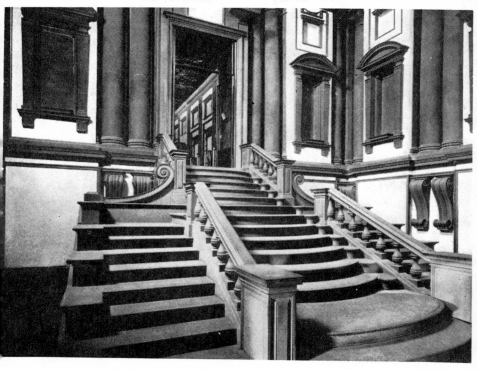

1. Florence: Biblioteca Laurenziana, vestibule

2. Florence: Biblioteca Laurenziana, interior

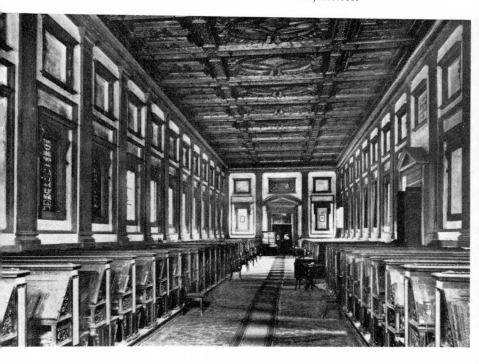

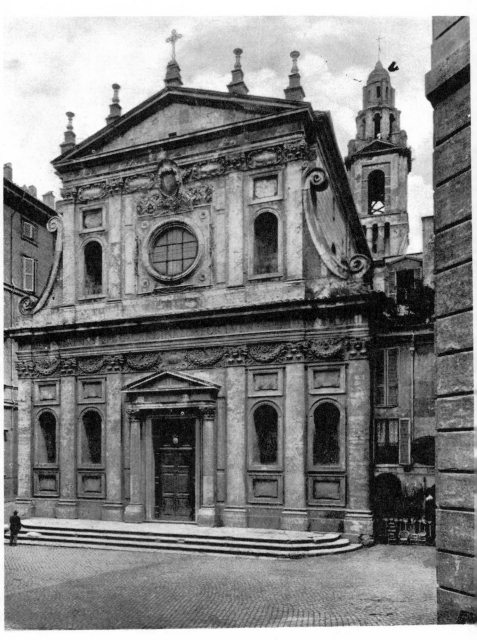

3. Rome: S. Caterina de' Funari

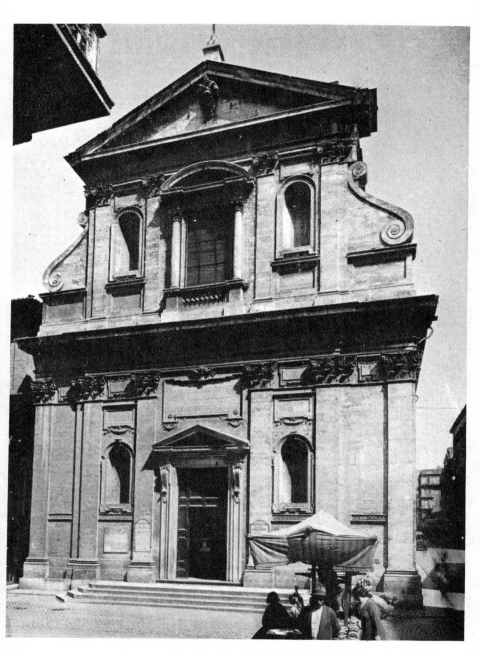

4. Rome: S. Maria ai Monti

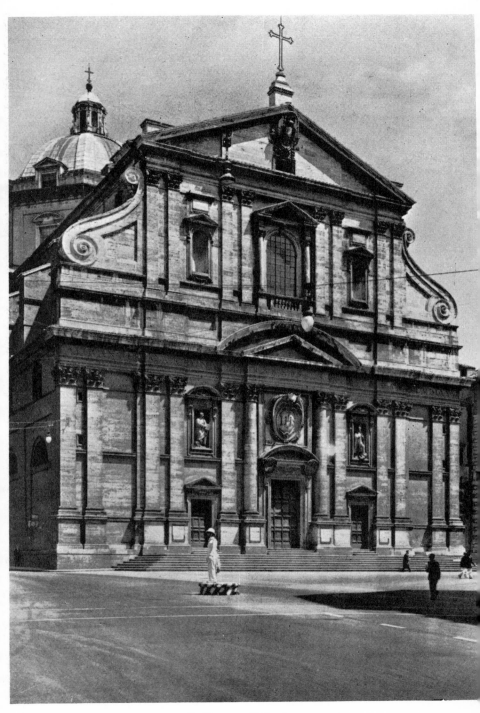

5. Rome: Il Gesù

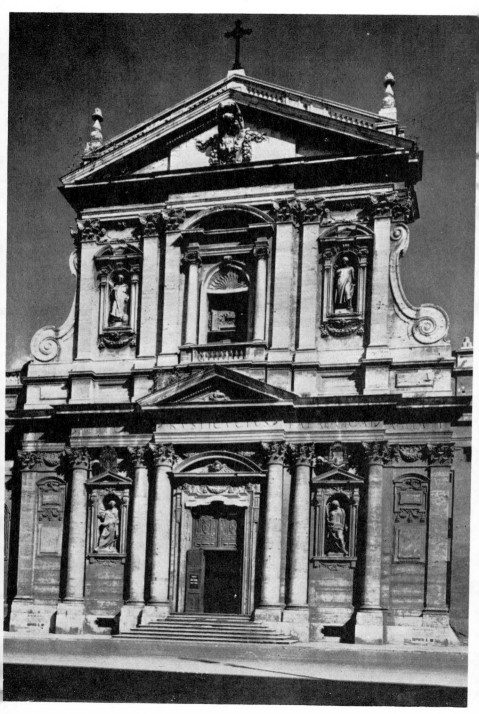

6. Rome: S. Susanna

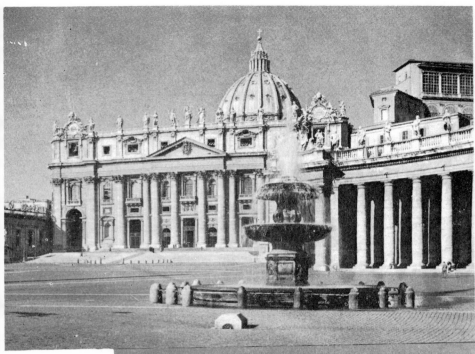

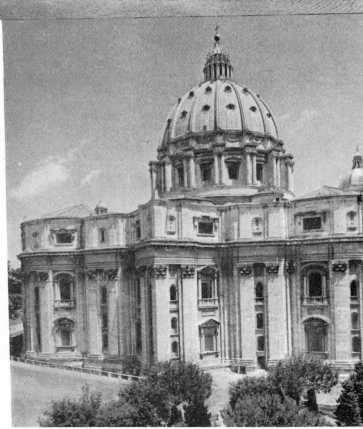

7. Rome: St. Peter's façade

8. Rome: St. Peter's rear

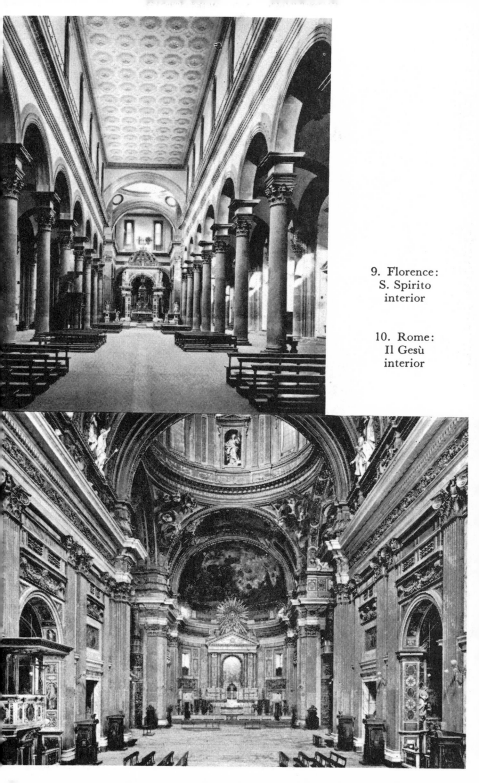

9. Florence:
S. Spirito
interior

10. Rome:
Il Gesù
interior

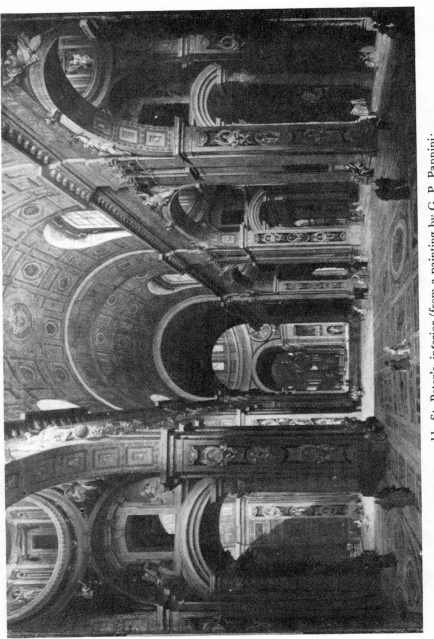

11. St. Peter's, interior (from a painting by G. P. Pannini; reproduced by courtesy of the Trustees, The National Gallery, London)

rider in *Heliodorus*.[3] Eventually the whole composition, whether of figures or of architecture, is given an oblique axis; when a painting is seen from below, that is, when its vanishing point is high, there is the added effect of a sloping recession.

Unpainterly, finally, is the symmetrical composition. In the painterly style, there is only an equilibrium of the masses, with no neat correspondence of the individual forms to each other; sometimes the two sides of the picture are quite dissimilar, and the centre of the picture is undefined. The centre of gravity is transferred to one side, giving the composition a peculiar tension. A free painterly composition has no structural framework, no rule in accordance with which the figures are arranged; it is dictated only by an interplay of light and shade which defies all rule.[4]

The third element in the painterly style may be called *elusiveness*, the lack of definition. It is characteristic of 'painterly disorder' that individual objects should be not fully and clearly represented, but partially hidden. The overlapping of one object by another is one of the most important devices for the achievement of painterliness, for it is recognised that the eye quickly tires of anything in a painting that can be fully grasped at first glance. But if some parts of the composition remain hidden and one object overlaps another, the beholder is stimulated to imagine what he cannot see. The objects that are partly hidden seem as if they might at any moment emerge; the picture becomes alive, and the hidden parts then actually do seem to reveal themselves. Even the severe style could not always avoid overlapping objects, but all the essential features stood out clearly and any restlessness was softened. In the painterly style the composition is purposely arranged in such a way that the effect is an impression of transitoriness. A similar device is the partial concealment of the figures by the frame, so that all we see of them is half-figures looking into the picture.

It is, in fact, on the indefinable that the painterly style ultimately depends. If the dissolution of the regular is the opposite of the structural, then it is also the antithesis of the sculptural. Sculptural symmetry avoids the indefinite and un-finite, the qualities most essential to the painterly style. For this does not work through individual forms, figures and motifs, but large masses, not through clear definition, but indefiniteness, limitlessness and infinity. A painting in the old style contained a limited number of figures, easily intelligible as individual forms and as a composition. In the baroque the number of figures became ever greater – one may note the steady increase in the Stanze – and melted into the dark background; the spectator, not minded to follow up individual elements, is content with a general effect. Since he cannot possibly absorb every single thing in the picture he is left with the impression that it has unlimited potentialities, and his imagination is kept constantly in action, a reaction, of course, intended by the painter. A painterly fold of drapery, landscape or interior owes its charm largely to this apparent inexhaustibility and lack of definition, with its perpetual stimulus to the imagination. How unlimited and inscrutable is the spatial structure of the Heliodorus compared with the School of Athens!

Ultimately the painterly style had to lead to a total annihilation of three-dimensional form. Its real aim was to represent all the vitality and variety of light, and for this purpose the simplest subject was as suitable as the richest and most painterly profusion.

It is a common error to confuse 'painterly' and 'colourful'. Our analysis of the painterly style shows that variety of colour was quite unnecessary to it. Indeed Rembrandt, the greatest master of the painterly, preferred the medium of the etching, a technique that works only with variations of light and dark. If colour, therefore, was a useful additional element to increase atmospheric quality, it was not an

essential component of the painterly style. The important thing is that in the baroque style it was not used to make a chromatic harmony in which each colour brings out the purity and the local qualities of its neighbours; local effects, on the contrary, were broken up with infinite modulations and transitions and subordinated to a unifying tonal scheme, so that nothing could disrupt the main effect based on an interplay of light and shade. Again the works of Raphael marked the transition from one attitude to the other. The enclosed, even monochromatic areas of colour in his earlier style gave way to colours changing and transforming themselves in all directions, full of life and movement.

The history of ancient sculpture offers another instance of the difference between 'painterly' and 'colourful'. The practice of colouring statues ceased at the precise moment when the painterly style began, that is, when the effect of light and shade came to be confidently relied on for the main effect.[5]

It seems that we have now rehearsed the main constituent elements of the painterly style. The possibilities of painterliness in sculpture are, of course, more limited; but even here it was possible to achieve by means of light and shade a composition which would cater to a taste for animated masses. Line was abolished; this meant in terms of sculpture that corners were rounded off, so that the boundaries between light and dark, which had formerly been clearly defined, now formed a quivering transition. The contour ceased to be a continuous line; the eye was no longer to glide down the sides of a figure, as it could on one composed of flat planes. It was led further and further round to the back of the form; an angel's arm by Bernini is like a vine-column. Just as no need was felt to make the lines of contours continuous, so there was no urge to treat the surface in a simpler way; on the contrary, the clearly-defined surfaces of the old style were purposely broken up with 'accidental' effects to give them greater vitality.

The same happened in relief sculpture. Whereas one could imagine the Parthenon frieze with a gold ground, which might form an effective foil to the beautiful contours of the figures, this would not be possible with a more painterly relief like the Pergamene Gigantomachia, which relies entirely on the effects of moving masses, and for which a gold ground would only create a wild and completely inappropriate confusion of colour.

But our subject is architecture, and there is no further need to analyse how far the painterly method was, or could be, applied to sculpture. Let us return therefore to our original thesis, which is that in the baroque period architecture became painterly, and that this quality is an essential characteristic of the baroque style.

It is not certain that the baroque should be approached in terms of the attitudes analysed here, and I believe that painterliness cannot properly be said to form the basis of the baroque style. For one thing, to approach it in this way might imply that architecture sets out to imitate a different art form, whereas what we are discussing is a general approach to form which embraces all the arts, including music, and which implies a more fundamental common source. What, in any case, have we said with the word 'painterly'? Does it mean that architectural forms are deprived of their solidity in order to provide what is simply an optical illusion? This cannot be so, because it would then follow that all inorganic styles are painterly. Does it mean that architecture is used as a means of suggesting movement? If so, we may at least have found a partial definition of the baroque style, but only a partial one, because French rococo also possesses movement and yet is very different from baroque. The light skipping movement of rococo is quite alien to Roman baroque, which is ponderous and massive. It follows that massiveness must be another ingredient of the baroque style; but we have now overstepped the bounds of

painterliness, and it becomes clear that this 'painterliness' is too general a concept to offer a comprehensive definition of baroque.

We should therefore do better to deduce the characteristics of the baroque style by comparing it with what went before, that is, with the Renaissance; this should make it clear what kinds of forms can be defined as painterly. We shall have to compare not only the individual forms of both styles, such as cornices and columns – for to do no more than this would be both unphilosophical and unscientific – but to find attitudes which exert an influence on form in general.

II. THE GRAND STYLE

Renaissance art is the art of calm and beauty. The beauty it offers us has a liberating influence, and we apprehend it as a general sense of well-being and a uniform enhancement of vitality. Its creations are perfect: they reveal nothing forced or inhibited, uneasy or agitated. Each form has been born easily, free and complete. Its arches are pure semicircles; proportions are broad and pleasing. Everything breathes satisfaction, and we are surely not mistaken in seeing in this heavenly calm and content the highest expression of the artistic spirit of that age.

Baroque aims at a different effect. It wants to carry us away with the force of its impact, immediate and overwhelming. It gives us not a generally enhanced vitality, but excitement, ecstasy, intoxication. Its impact on us is intended to be only momentary, while that of the Renaissance is slower and quieter, but more enduring, making us want to linger for ever in its presence.[1] This momentary impact of baroque is powerful, but soon leaves us with a certain sense of desolation.[2] It does not convey a state of present happiness, but a feeling of anticipation, of something yet to come, of dissatisfaction and restlessness rather than fulfilment. We have no sense of release, but rather of having been drawn into the tension of an emotional condition.

This general effect, which we attempted to define in the last chapter, results from a certain treatment of form which we shall now describe under the two main headings of 'massiveness' and 'movement'. A third heading could be Vasari's 'maniera grande',[3] the quality of monumentality

38

which was so well suited to the baroque, even if to a certain extent the grand style follows naturally from the search for massiveness. This 'maniera grande' consists of two elements; one is an increase in size, the other simpler and more unified composition.

After the activity of Michelangelo and Raphael in the Vatican, painting, sculpture and architecture increased steadily in scale; until beauty was conceived of entirely in terms of the colossal. Gracefulness and diversity gave way to a new simplicity, aiming only at large masses; the whole is permeated by a powerful and unifying force and nothing suggests a composition made up of separate parts.

The native Roman sense of monumentality had been given a new impetus in the Renaissance by the grandiose building projects of the popes. The most important single building was St. Peter's. Here was a new standard which suddenly made all earlier buildings seem small and provided a great and perpetual challenge for the enthusiastic church builders of the Counter-Reformation.

In domestic architecture there was a similar desire to impress by size. Once Cardinal Alexander Farnese had raised the façade of his palace from 140 feet to 195 feet as a sign of his new dignity[4] on becoming pope, the fashion for huge palaces quickly became universal. Only a few examples can be mentioned: the Palazzo Farnese in Piacenza, which was influenced directly by its Roman model, the villa of the Farnese at Caprarola, both by Vignola; and the Roman palaces of the papal *nepoti*, each of whom tried to outdo the others. Even the villa lost its serenity in the pursuit of the new ideal. The greatest achievements of Florence seem relatively small by comparison with these buildings, with the single exception of the Palazzo Pitti and even this is largely baroque, for Brunelleschi's building had only half the present façade.[5]

Increasing size is a common symptom of art in decline;

or, more accurately, art is in a state of decline from the moment that it aspires to massiveness through colossal proportions. There is no longer a response to individual parts, and the formal sensibility becomes coarsened; the sole aim is to impress and overwhelm.

This style is better served by large unarticulated masses than by many separate parts. It aims at broadness and unity rather than detail or variety;[6] the progress from one to the other may be detected in the principles of composition as well as in its component parts.

Larger buildings naturally demanded simpler and more effective detail. The architrave was reduced from three to two units, and the profile of the cornice simplified to a few vigorous lines; the baluster, which had once consisted of two equal sections, became a single shaft, a form first used by Sangallo and Michelangelo (figs. 1 and 2).[7]

This principle of simplification also became decisively

Fig. 1 Baluster, after Raphael

Fig. 2 Baluster, after Michelangelo, from the Capitoline steps

important for the composition as a whole, for the ground plan and the elevation. Façades consisting of a series of equal storeys became unacceptable; the 'grand style' demanded that the façade should reveal itself as a unified body.

In this development the most difficult problem was natur-
ally posed by the palace. Rome led the way once again, and
the moving spirit was Bramante himself; his 'ultima maniera'
shows a definite move towards the *vertically unified façade*.
Even he had outgrown the style of the Cancelleria with its
three equal storeys; the ground floor now became a pedestal
for the whole building. The most determined innovator was
Michelangelo, in whose Capitoline palaces the two storeys
are boldly held together with a single order of giant pilasters
(pl. 15). Palladio followed him in this practice, but it found
no imitators in Rome, where vertical members became un-
popular and other ways of conveying the impression of
unity had to be found. The method used was to make one
storey much larger and richer than the others, but it was
left to a later age, in the person of Bernini, to create the
model which combined the giant pilaster order with the
ground floor as pedestal; this was to have the greatest sig-
nificance for monumental architecture.[8]

Venetian architecture continued along the same lines as
before; the freely rhythmic disposition of masses was never
understood there, and all palaces after Longhena's Palazzo
Pesaro (*c.* 1650) consisted of a series of elaborate storeys
equally accentuated. Even Palladio's palaces often had two,
or even three, similar storeys.

The Cancelleria is as typical of the Renaissance in its
horizontal articulation as it is in its vertical. The pilasters are
placed so as to divide the wall surface into large bays, each
enclosed by two smaller ones; the ratio of the smaller to the
larger is determined by the golden section.[9] This motif was
called by Geymüller 'Bramante's rhythmic travée' (pl. 16).
It is a characteristically Renaissance conception,[10] and is
often combined with a central arch, the motif becoming that
of the triumphal arch. Its significance lies in the interplay of
large and small pilaster bays; the small ones are always

small enough not to disturb the predominance of the large one, yet not so small that they lose their meaning as individual forms.

The baroque firmly repudiated this principle of articulation. Absolute unity became the rule, and subordinate parts were sacrificed. The high altar of the Gesù by Giacomo della Porta shows the transformation which the triumphal arch motif had undergone. The central arch is large, the side arches are stunted, and the columns placed so close together that they are almost coupled (pl. 10).[11] The same kind of transformation can be seen in the niche if we compare Bramante's niche with that (probably by Antonio da Sangallo) on the centre landing of the staircase in the Giardino della Pigna in the Vatican.

In northern Italy the old Renaissance modes continued to be followed in this respect also, as in the much imitated interior system of S. Fedele in Milan by Pellegrino Tibaldi, with its twice-repeated triumphal arch motif, and in the exterior articulation of Longhena's S. Maria della Salute in Venice.

A similar process of unification took place in the spatial organisation of the *interior*. Self-contained subordinate spaces made way for one single overwhelming central space. The ground plan followed a development parallel to the 'rhythmic travée'. In the Florentine basilicas of the early Renaissance, S. Lorenzo and S. Spirito, the aisles are in the ratio of 1:2 to the nave, a proportion also used in the articulation of wall-surfaces, as in the façades of Alberti. Bramante's first project for St. Peter's had subsidiary crossings with cupolas in the proportion of the golden section to the central crossing, after the manner of the Cancelleria. In the succeeding plans the side spaces became progressively smaller; the final development, in Vignola's longitudinal Gesù, had only a nave with chapels which, though interconnected, do not act as independent aisles (pl. 10). The Gesù became

the model for all churches in Rome. The three-aisled vesti-
bule had a similar development which can be followed
from Raphael's Villa Madama to Antonio da Sangallo's in
the Palazzo Farnese. Subdivision of space remained exclu-
sive to northern Italy.

The Renaissance took a delight in a system of greater and
lesser parts, in which the small prepared one for the large
by prefiguring the form of the whole. It is for this reason
that even colossal buildings like the St. Peter's of Bramante
have a less than overwhelming effect. The baroque has
large forms only. This is evident if we compare Michel-
angelo's project for St. Peter's with Bramante's. In Bra-
mante's first plan the arms of the Greek cross are twice
repeated in decreasing proportions, like a sort of dying echo
of the colossal motif, whereas there is no trace of such a
modification in Michelangelo's design (figs. 18 and 19). The
articulation of the wall follows an even more typical course.
Bramante, beginning with a two-storey system, had himself
finally adopted a single colossal order; but he had kept small
columns for the ambulatories at the ends of the arms, and
these, more nearly approaching human proportions, affor-
ded the beholder some repose and brought the colossal with-
in his grasp. Michelangelo does away with the transitional
ambulatories. The baroque is a search for the intimidating
and overwhelming.

III. MASSIVENESS

The baroque required broad, heavy, massive forms. Elegant proportions disappeared and buildings tended to become weightier until sometimes the forms were almost crushed by the pressure. The grace and lightness of the Renaissance were gone; all forms became broader and heavier. We only have to look at the balustrade of Michelangelo's staircase to the Capitol to appreciate this (pl. 25). A similar transformation is characteristic of pilasters and piers.[1]

Church and palace façades were given as much width as possible; the façade of St. Peter's, for instance, is artificially widened with turrets at the angles. Moreover, from the time of the Palazzo Farnese, palace façades were not articulated vertically; they lost their pilasters, even in buildings of nineteen bays such as Ammannati's Palazzo Ruspoli. On church façades the verticals were retained, but great projecting cornices and horizontal accents provided a strong counterweight to them.

One of the most direct ways of suggesting weight and oppressiveness was by a heavily depressed pediment. A shallow pediment gives a sinking rather than a rising effect, emphasised by a base-line which projects beyond the corner of the building; this practice is first to be seen in della Porta's design for the Gesù, where the effect is increased by heavy acroteria on both sides. Low pedestals and high attics pressing down on the supporting members, were also used.

The design of staircases showed how much satisfaction

44

was found in low, spreading forms. The aim was to 'salire con gravità', ascend with gravity, in Scamozzi's words, and often the steps were so shallow that they were uncomfortable to walk on. This was carried to a monstrous degree in the curved staircase leading up from the Piazza to the church of St. Peter's, which looks like some viscous mass slowly oozing down the slope. There is no suggestion of ascent, only of downward movement.

This effect of yielding to an oppressive weight is sometimes so powerful that we imagine that the forms affected are actually suffering. The serene semicircular arch was depressed into an ellipse, first of all in the second storey of the Palazzo Farnese;[2] the tall, slender pedestals which had contributed so much to the feeling of lightness in earlier buildings now became low and uncomfortable, and, in the vestibule of the Palazzo Farnese, for example, one cannot help feeling the weight of the burden.

These forms were enlarged by *Michelangelo*. The colonnade in the Palazzo dei Conservatori (pl. 15) have positively unpleasant proportions, the upper storey pressing down so heavily on the small columns that they in turn seem to be pushed against the giant piers. We feel they are there only under duress. This sensation is partly caused by the irrational and perverse intervals between the columns; they are so uncomfortably close as to be unsatisfying and consequently unnatural.[3]

The pleasure found in treating matter with violence could only lead to a tendency to *amorphousness*, and an architect as unscrupulous as Giulio Romano carried this to its utmost extreme. In the Sala dei Giganti in Mantua form is completely annihilated; raw, unformed masses break in, unhewn boulders take the place of cornices, corners are bevelled off. Everything bursts its bounds and chaos triumphs. But this is an exception, and hardly contributes to the general character of baroque. We can also excuse

naturalism in 'rustic' fountains and in landscape architecture, where matter appears entirely formless.

The broad forms of the baroque style are part of a totally new conception of *matter*, that is of the ideal aspect of matter which gives expression to the inner vitality and behaviour of the members. The hard, brittle stuff of Renaissance architecture has suddenly turned supple and soft; sometimes it almost reminds us of clay. In fact Michelangelo actually made clay models of such architectural features as the undulating staircase of the Laurenziana,[4] and its form shows it, as Burckhardt observed.[5] The response to paint is similar; if we compare a landscape by Annibale Carracci with one of the early Florentine Renaissance – to take the strongest possible contrast – we find, in place of sharp angular rock formations, a clayey mass of a rich blue-green hue suffused with light. The same development from an angular, almost metallic style to a wealth of soft masses and lushness can be observed in everything. The same Annibale Carracci finds a late figure by Raphael 'as hard and as sharp as a piece of wood' ['una cosa di legno, tanto dura e tagliente'].[6] As early as Vasari the dryness of Bramante's early Roman style of the Cancelleria is criticised; 'secchezza' was something hated by the baroque.

As matter becomes soft and masses fluid, structural cohesion is dissolved; the massiveness of the style, already expressed in the broad and heavy forms, is now also manifested in inadequate articulation and lack of precise forms. To begin with, a *wall* was now regarded as a single uniform mass, not as something made up of individual stones. Stone courses ceased to be used as an aesthetic motif; when possible they were covered up. The Renaissance manner is best illustrated in the neat ashlar of the Cancelleria, in which the side façades also show a most elegant use of brick. But now the general practice was to cover brick with stucco, after the example of the Palazzo Farnese.[7] The stone block (in Rome

the splendid travertine used since antiquity) lost its meaning as an individual component, so that there were no more rusticated façades; the experiments of Raphael and Bramante on the ground floors of palaces (figs. 27 and 28) were never repeated.[8]

One might almost say that the baroque style deprived the wall of its tectonic element, that the mass of which the wall is composed lost its inner structure. And if the wall consisted of materials other than rectangular blocks, there was no reason why straight lines and right-angles should be retained. *All hard and pointed shapes were blunted and softened, and everything angular became rounded.*

The love of fullness and softness was a Roman taste. The Florentine style remained much drier and harder and even Michelangelo's origins sometimes betray him. The easiest point of attack for this new conception of form lay in ornament. If we look at the coat-of-arms by Michelangelo on the Palazzo Farnese, dating from about 1546, at Nanni's on the Porta del Popola, or della Porta's on the Gesù, we see that here the baroque ideals were put into practice quite early on. If we compare them with, say, the coat-of-arms on the corner of the Cancelleria, the contrast is immediately obvious. The Renaissance work looks fragile, its brittle stuff terminates in sharp edges and hard angles, while the baroque forms are full, opulent, and curled over in round and generous whorls. Cartouches were also treated in this way, quite different from the Florentine or north Italian manner that reminds one of strips of leather. Michelangelo's famous Ionic capitals on the Palazzo dei Conservatori are another case in point (fig. 3).

Marble was almost entirely replaced by travertine, which had been given to nobility in the decoration of the Farnese courtyard;[9] its spongy 'spugno so' character lent itself well to a baroque type of treatment, whereas marble, which has a finer grain, demands a more delicate technique.

47

In architectural forms the soft, full forms appeared in bulging friezes and such pedestals as that of the base of the

Fig. 3 Capital, Palazzo dei Conservatori, ground floor

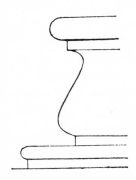

Fig. 4 Profile of pedestal from the Palazzo Farnese

Palazzo Farnese (fig. 4), and in the gable-ends terminating in snail-like whorls first used by Michelangelo in the sarcophagus-lids of the Medici chapel in S. Lorenzo and later by Vignola on the main portal of the Gesù (fig. 15). The composition of volutes will be discussed presently. Stylised wreaths and bunches of leaves were used to make bizarre friezes; in the Lateran basilica even archivolts and pilasters were decorated with thick clusters of palm leaves.

Particular care was taken to see that the profiles of mouldings should be soft and fluid. Their component parts were merged into one continuous line; *right angles were avoided altogether.*[10] Two of Bramante's profiles from the Cancelleria set against two later ones (fig. 5), show the sharp, precise and detailed work of the Renaissance, and by contrast, the attempt to create a soft fluidity in the early baroque. This antipathy to the right-angle was so strong that no inhibitions were felt about letting structural surfaces abut in a very marked curve. The earliest instance of this was the base of the Porta di S. Spirito by Antonio da Sangallo (fig. 5),

48

the next was the exterior of the apse of St. Peter's, by Michelangelo. In the severe style no straight surface could ever have departed from the vertical.

On the same basis angles were rounded off even in ground plans. So much, in fact, was the sense of structure lost sight of that walls were soon made convex or concave at will; this was part of the increasing tendency to convey a feeling of movement and will therefore be discussed below in the appropriate place.[11]

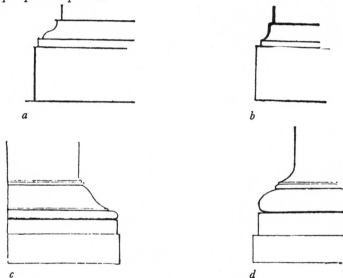

Fig. 5 Profiles of column bases from *a, b,* Cancelleria
c Palazzo dei Conservatori *d* Porta Santo Spirito

The third decisive element of baroque was the incomplete articulation of masses. Architectural members kept a quality of massiveness because they were little differentiated. They are not clearly bounded forms with an independent existence; the individual element was deprived of its value and force, and structural members were multiplied and lost their independent mobility, imprisoned in the material. The architectural body as a whole remained tightly pressed

together, largely unarticulated both in plan and elevation. The serenity of Renaissance architecture had been achieved precisely through the loosening of the mass, in the happy articulation of the whole and the freedom of individual members; the baroque implied a reversion to a more amorphous state.

One symptom of this was replacement of the column by the *pier*. The solemnity of the pier lies in its being materially confined. The column is round and free and clearly detached from the mass, it is all will and vitality; but the pier always remains so to speak with one foot stuck in the wall and, lacking the independence of the cylindrical form, communicates a sensation of massiveness.

In the lively seaports of Genoa, Naples and Palermo, and on the whole in Florence too, the column was never abandoned. But the early baroque in Rome was completely dominated by the pier, and the column did not return until about the middle of the seventeenth century.

The disappearance of light arcaded courtyards and loggias was a particularly noticeable feature. The complete change of mood is epitomised by the difference between the cortile of the Cancelleria (pl. 16) and that of the Palazzo Farnese (pl. 17); the latter is overwhelmingly solemn. In churches piers became necessary for reasons of construction, because columns were not strong enough to carry the heavy barrel-vaulted ceilings. The piers became broad, unarticulated stretches of wall. But this was not enough to convey the impression of massiveness; the arches between them were made to terminate considerably below the architrave, and the keystone was omitted. This one finds in the interior of the Gesù (pl. 10) and, at an even earlier date, in the main windows of the Villa Farnese at Caprarola, and later examples occur in S. Maria ai Monti by Giacomo della Porta, the façade of S. Gregorio Magno by Soria (fig. 17), and the façade of the Scala Santa by Domenico Fontana.

In northern Italy, where brick was the chief building material, piers had been used for a long time as a matter of structural necessity, but there they had been given a certain grace by slender proportions and by partition into four pilasters (fig. 6); the church of S. Giovanni Evangelista in Parma and S. Salvatore in Venice are examples. Translated into baroque terms this same pier, composed of four pilasters, looked like the one from the Palazzo dei Conservatori shown in fig. 7; the mass is no longer completely articulated or bound by the pilasters, but emerges at the corners.

Fig. 6 Scheme of section of a Renaissance pier

Fig. 7 Scheme of section of Baroque pier

The substitution of the pier for the column naturally meant also the substitution of the *pilaster* for the half-column. The progress from colonnade to pier arcade is illustrated in the courtyard of the Palazzo Farnese (pl. 17), the Sapienza (pl. 20) and the Collegio Romano of Ammannati.

A common practice of the transitional period was to tie the half-columns and pilasters to the wall and frame them with great rusticated blocks. Serlio, much given to this kind of thing, justified it by pointing to the example of Giulio Romano; Vignola used it for gateways, mostly in rustic settings.

The most advanced expression of imprisoned matter was achieved by *Michelangelo*: here form struggles with mass. We saw the same development in the columns of the Capitoline palace, which appeared to be pushed by sheer weight

against the giant piers (pl. 15). Here too is the sense of suffering, the members that appear unable to free themselves from the suffocating embrace of the wall. In the vestibule of the Laurenziana (pl. 1) the columns do not even emerge beyond the surface of the wall but are held as pairs in recesses. The composition has no sense of satisfaction or fulfilment, or of necessity, so that it creates an impression of constant movement, an unending process of impassioned agitation and furious struggle between form and mass. It is a unique manifestation of the baroque spirit, doubly unique in the superb way in which the stormy prelude is resolved in the main room at the top of the staircase where suddenly everything is calmness and repose; the vestibule, we now see, was only an introduction to this second and nobler effect. We shall have more to say later about this kind of composition by contrasts; only Michelangelo ventured such a thing.

In the colonnade of the Palazzo dei Conservatori the motif is repeated in a slightly different form. Michelangelo made all the forms in the porch as massive as possible in order to secure a maximum contrast with the interior. The columns are not free from the wall, yet they are not half-columns but rather whole ones which have not yet won their freedom. Perhaps half protrudes beyond the wall and the rest is still immured in it (fig. 8). In this way we are given the impression of an unceasing, restless struggle for liberty. Later the motif of the 'imprisoned' columns, to coin the term, was often used in varying degrees, anything from a quarter to three-quarters being free. For façades it was useful for the strong shadow cast in the recess on both sides of the column. In

Fig. 8 Section of an 'immured' column

the second period of the baroque the column was freed again, and always backed by a pilaster.

In the Renaissance every architectural member was simply and purely stated, while in the baroque *members were multiplied*. The main reason for multiplication was the abnormally large proportions which demanded more vigorous forms, [12] but soon it became quite usual to repeat forms several times over, encasing, for instance, pediments in pediments. Single forms lost their power to convince; any form that was to have more than purely accidental effect had to be reproduced twice or three times. Once simple statements were abandoned, there was nothing to set a limit. Another factor was the multiplication of contours in the interests of painterly effects. The single, clear and self-sufficient line was replaced by a kind of formative zone, a complex of lines which made it difficult to recognise the actual contour. This resulted in an illusion of movement, a suggestion that the form had first to move into its allotted position.

Superimposed pilasters were of this kind. These were pilasters flanked on each side by a receding half-pilaster, and later even by a further quarter-pilaster. It probably originated in brick buildings, where it would have constituted an easy adaptation of the rounded half-column. Something similar sometimes occurs in quite early buildings in the Romagna and Lombardy: the church of S. Cristoforo in Ferrara is an example. A different source is suggested by the loggia in the Farnesina, where the wall shows the same motif fully developed. Here the intention is quite different; the pilaster is a two-dimensional echo of the corresponding pier, and it is conceivable that this effective motif was transferred from there to the façade.

The earliest superimposed pilaster in Rome is to be found in the first storey of Bramante's Belvedere courtyard.[13] Peruzzi used it in the Palazzo Costa and Michelangelo in

the second storey of the Farnese courtyard (pl. 24), and general imitation followed.

A related form was the *flat, framing strip* sometimes surrounding three sides of a pilaster bay. It is so to speak a pilaster in embryo. Again it is not a definite, simple statement of form, but a transition, a blurring of contours, often reminding one of a chromatic scale in music.[14] The wall recess or, to keep to our first term, the pilaster bay framed with a flat moulding, appears to be another motif derived from brick architecture. We find it in the buildings of Peruzzi, who as a Sienese was well acquainted with this material, and later as an important feature with Michelangelo (pl. 8).

The duplication of terminating members was another aspect of the habit of compounding. The forms ceased to have well-defined boundaries at the top and bottom, they became hesitant and unable to decide where to finish. The first example must be the piers in the cortile of the Palazzo Farnese (pl. 17), and if we compare the bases and double cornices of this building with the simple and assured forms of Palladio's courtyard in the Carità in Venice, the difference between the two conceptions will be clear. The tomb of Paul III, by Gulielmo della Porta, has a base of this complex sort and columns come to be provided with double plinths. The contours of attics on church façades underwent the same treatment, as in della Porta's design for the Gesù (fig. 16) Vignola's project in comparison with (fig. 15). The lines of the cornice seem to be echoed several times over, the termination is inconclusive.

The sense of massiveness was largely effected by omitting the framing members which enclose and subordinate the material. In this respect baroque is the extreme opposite of the gothic style. Gothic emphasises the framing members. It has firm structural supports, lightly filled in, whereas *the baroque puts the emphasis on the material*, and either omits the

frame altogether or makes it seem inadequate to contain the bulging mass it encloses. The Renaissance follows a middle course, keeping a perfect equilibrium between the filling and the enclosing structural members. The decorated pilaster of the Renaissance is inconceivable without its frame; in the baroque this enclosing frame is abandoned and the ornament allowed to luxuriate unchecked. Early examples of this practice are Michelangelo's tomb of Julius II in S. Pietro in Vincoli, and the Cappella Cesi in S. Maria della Pace by Antonio da Sangallo and Simone Mosca. The coffered barrel-vault was formerly encased in a frame moulding omitted in the baroque, in which the coffers cover the entire vault without any framing. This can be seen in the Cappella Corsini in the Lateran, by Galilei, which is in other respects one of the purer works of the late period.

The *corners* of buildings were designed according to the same ideas. The same contrast between gothic and baroque, the one accentuating the structural members and the other the filling-in, should be kept in mind. Giotto's campanile in Florence has little projecting towers in miniature at the corners; everything depends on the strong frame. In the Renaissance wall surfaces terminate with a simple pilaster, first a single, later a double one. In the early baroque period the pilaster is moved inwards, leaving the bare wall to form a corner by itself, as can be seen in Vignola's Capitoline porticoes, or the porch of S. Maria in Domnica, wrongly attributed to Raphael. The superimposed pilasters creates a whole complex of lines at the corner so that it becomes hard to recognise; this we can see in the tomb of Paul III by Gulielmo della Porta, and in Soria's S. Gregorio Magno (fig. 17). As a matter of principle the baroque avoids displaying corners; it is concerned with façades and their outer parts are kept as inconspicuous as possible. The vigour and magnificence are thrown to the centre.

This is effectively enhanced by making the decorative

filling too large, so that it overflows its allotted space. Extreme effects of this kind cannot of course extend to the whole composition; they are only possible for details where the discord can eventually be resolved. One example is the decoration of ceilings; the filling of the coffers was composed in a way that suggested a perpetual state of friction between recess and frame. In a Renaissance ceiling all elements are happily harmonised, everything has air and space; but baroque ceilings are crowded and massive and make us fear that the filling will burst out of the frames. The first such ceilings are by Sangallo in the Palazzo Farnese. The cramped niches on church façades will be discussed later.

In the decoration of dome pendentives the same occurs in the figures by Domenichino in S. Andrea della Valle, too large for the space they fill; in the later stages there were no scruples at all about ornament overflowing in this way. In St. Peter's we can see how the figures in the spandrels of the nave arches gradually become larger towards the entrance; those at the end, the most recently executed, are the most expansive. The same phenomenon is seen in the statues which fill the niches. Statues in general only appealed when they threatened to burst their niches.

The mass of the architectural body as a whole remained unevolved, with no developed plan. Loggias and similar forms disappeared. The size of all openings diminished in relation to the wall. The ideal church façade was an unbroken wall of travertine, and with the palace it was the same. Already there were cases when an entrance arch stopped short of the cornice, leaving an uninterrupted stretch of wall in between. This motif imparted a sense of uneasiness.

The façade was left unarticulated. Even the grand style had demanded façades subdivided as little as possible, cast as a single piece. The unity was not complete, but the subsidiary parts were left in a dependent state; it was this that constituted an incomplete articulation. The Renaissance had

found its highest fulfilment in the conception of a whole that consisted of a harmonious combination of individual self-contained parts. A favourite design had been the church façade with free-standing wings that reproduced the motif of the central part in miniature, as in S. Maria di Campagna in Piacenza. This would have been out of the question in a baroque church, where the subsidiary parts were kept in-articulate and imprisoned in the main mass of the building, never attaining independence.

The same was the case with the ground plan: it remained unevolved. The bnilding never progressed beyond the state of a compact mass. And yet how much the vitality of a building depends precisely on dispersal of the mass! What would Palladio's Villa Rotonda be without its porticoes? Or the Farnesina (pl. 29) without the charming motif of projecting wings, apparently given complete liberty? Such a thing was impossible in a baroque building; if there were wings they were never free from the main mass, for there would have been no means of linking them to it. Only with the later baroque is there a return to freer forms.

IV. MOVEMENT

Massiveness and movement are the principles of the baroque style. It did not aim at the perfection of an architectural body, nor at the beauty of 'growth', as Winckelmann would put it, but rather at an event, the expression of a directed movement in that body. Where on the one hand mass became greater, on the other the strength of the members was increased, though not in such a way as to influence the whole structure uniformly. Rather did the baroque concentrate the whole strength of the building at one point, where it breaks out in an immoderate display while the rest remains dull and lifeless. The functions of lifting and carrying, once performed as a matter of course, without haste or strain, now became an exercise of violent and passionate effort. At the same time this action was not left to the individual structural members, but infected the whole mass of the building; its whole body was drawn into the momentum of the movement.

In contrast to Renaissance art, which sought permanence and repose in everything, the baroque had from the first a definite *sense of direction*. It expressed an urge for upward movement, and so the vertical force was opposed to the broad massiveness that we have already described, and became gradually stronger until eventually in the second period of baroque it outweighed the horizontals. *The motif of orientation* first asserted itself in individual features, in the *irregular distribution of ornament*. Windows were given an upward emphasis. The half-columns of the classical Renaissance aedicula were quickly shed and replaced by consoles,

but the pediments, far from being reduced in size, were made to project powerfully in order to cast a strong shadow. At the same time there was a widespread tendency to dissolve the horizontals, to *break up the forms*, a practice indulged in without any regard for the rights and meaning of the individual forms, with the purpose only of creating a painterly illusion of movement in the whole. Window jambs were extended downwards below the line of the sill, or upwards in a kind of 'ear'. The base-line of the pediment was broken in half, and later the apex also. Forms of this kind can usually be traced to Michelangelo, and the windows in the second storey of the Palazzo Farnese courtyard (pl. 24), themselves heralded by the Laurenziana, were of the greatest influence. In expressive contrast to the agitated individual features the large horizontals of the cornice remained undisturbed. The practice of bending forms was only very discreetly used during the first baroque period, mainly for entire wall surfaces. The contrasts obtained in this way were used to good effect until Maderna's time; the situation only becoming acute in the course of the seventeenth century, when every half and quarter pilaster tried to find an echo in the cornice and its effectiveness was completely destroyed. It was then too that all tectonic structural elements fell victim to a wild desire for movement, so that, for example, pediments piled up and were thrust outwards. We need not follow this development here.

The upward urge also expressed itself in an *accelerated linear movement*. This is the meaning of forms such as the herm-like pilasters that become wider as they move upwards, and seem to rise more quickly than straight unexpanding ones; we see them in the vestibule of Michelangelo's Laurenziana (pl. 1), on the tomb of Julius II, and later in some works by Vignola. The use of vine columns can be traced to the same desire for movement. The first of these on a monumental scale – judging by references in the later

editions of Vignola's *Regola* – would be on Bernini's baldacchino in St. Peter's (1633), although of course they appear earlier on Raphael's tapestry cartoons, where they are based on ancient models. In the early baroque period they were unimportant.

The expression of upward movement in the dome will be discussed in the chapter on ecclesiastical architecture.

The new taste was to be of the utmost importance for church façades. For one thing, it demanded an entirely new approach to the problem of surface treatment. The former balanced and satisfying relationship between window or niche and bay, in which each seemed to have been made for the other, was completely upset: the niche and its surrounding aedicula now strained upwards, so much so that they touched the architrave or the niche above it, leaving a large empty space below; and the fact that the niche was squeezed into a narrow bay and closely hemmed in by pilasters, made the upward movement appear even stronger.

There are certain symptoms here which recall gothic art, although gothic and baroque represent completely opposite ideals in all other respects. Even here the differences are vital, for in gothic the vertical movement streams upward without check and dissolves playfully at the top, while in baroque it encounters the resistance of a heavy cornice, though – and this is what matters – a harmonious solution is always found in the end.

In the upper parts of the building, surface and decoration coexist more peacefully; but any impression of complete calm was kept for the interior, and the contrast between the agitated idiom of the façade and the relaxed peace of the interior is one of the most compelling effects in the baroque repertory.[1]

This final calming of a violent upward surge derives from Michelangelo, and in the Laurenziana it is already fully developed (pls. 1 and 2).[2] The most important and in-

fluential design of this sort in Rome was probably the exterior of the apse of St. Peter's (pl. 8): the forms become purer and stiller as they ascend, and the façade motif[3] – unpleasing in itself – is resolved in the dome. Here we learn what, in the hands of such a master, constituted 'composition in the grand manner'.

The disposition of horizontals followed a development similar to that of the verticals. By concentrating the main emphasis on the centre, as much movement as possible was brought into the composition. This was in direct contrast to the great Florentine-classical conception, where the noblest effect had been a regular, harmonious disposition that excluded all display, even for principal doorways and windows.

In its simplest expression, this principle takes the form of a *rhythmic* sequence, as opposed to a merely regular and metric one.[4] Thus the windows in Giacomo della Porta's Palazzo Chigi follow each other in accelerating rhythm towards the centre, although the change of interval has no structural motivation. This concept was developed in the church façade, which in the hands of Giacomo della Porta became a system of partially overlapping sections, with the sculptural emphasis increasing towards the centre. The effort and the slow gathering of force is expressed by a progress from pilasters to half-columns and then to whole columns; above all, when clusters of columns pile up in the centre. The outermost bays remain almost entirely expressionless. The body is not uniformly animated.

The final consequence was that the whole wall mass surged: concave end bays were contrasted with a lively convex movement towards the spectator in the centre. This was the line that Michelangelo used in the notorious Laurenziana staircase (pl. 2).[5] The motif was first used on a large scale by Antonio da Sangallo[6] for the Zecca Vecchia (old mint)[7] and the Porta di S. Spirito, though with concave

walls only. The earliest full examples were in the churches of Borromini: in moderation in S. Agnese in Piazzo Navona, but carried to the utmost extremes in S. Carlo alle Quattro Fontane (1667).[8]

By making walls surge in this way the baroque achieved another purpose; since the pediments, windows, columns and other members followed the oscillation of the wall, the result was an impression of lively movement. Identical forms could be seen simultaneously at different angles; the columns, for instance, being orientated on varying axes, looked as if they were perpetually twisting and turning. Each member seemed to have been seized by a wild frenzy. It is this that characterises the art of Borromini. With it, however, the baroque necessarily lost its original massiveness and solemnity; blank walls became unacceptable and everything was dissolved in decoration and movement.

The baroque never offers us perfection and fulfilment, or the static calm of 'being', only the unrest of change and the tension of transience. This again produces a sense of movement, though of a different kind. *Tense proportional relationships* were part of this characteristic action. The circle is for instance an absolutely static and unchangeable form, but the oval is restless and always seems on the point of change; it lacks inner necessity. The baroque sought out such free proportions as a matter of principle; everything that was self-contained and complete was contrary to its essential nature. It used the oval, not only for medallions and similar objects, but for ground plans of halls, courtyards and church interiors. The form made its appearance early, as part of an agitated composition in a painting by Correggio (1515),[9] and this was at a time when no-one in Rome had thought of using it, either in painting or architecture. It was then taken up by Michelangelo for the plinth of the statue of Marcus Aurelius,[10] and passed on to Vignola; he in turn used it several times for medallions in the courtyard of the

villa at Caprarola, also for staircases. Giacomo della Porta transformed the semicircular theatre of the Belvedere courtyard (pl. 19) into the oval one of the Sapienza (pl. 20). The circular oculus disappeared from the church façade. The first elliptical ground plan occurred in an architectural treatise, Serlio's *Libri d'Architettura*,[11] but only much later it was applied in practice, as we shall see in connection with ecclesiastical architecture.

Similarly, the square gave way to the oblong. It is to be noted, however, that the oblong (and the ellipse), whose proportions are determined by the golden section, are stable compared with other, slimmer or more depressed forms. They are therefore avoided by the baroque, whereas they were universally accepted in the Renaissance. The most monumental manifestation of this new spirit was the abandonment of the centrally-planned church for the longitudinal one.

The ideal of tenseness was promoted by forms which were *unfulfilled to the point of discomfort*. Some of these have been mentioned already: the columns held back in recesses in the wall, the decorative fillings on the point of overflowing, and the church façades whose bays are filled with discordant decorations; every time an illusion of movement is generated.

Just as the baroque had achieved its purpose by means of the irregular and apparently incomplete, the unsettled and impermanent form, so it could put the 'painterly' device of *partial overlapping*, and intangibility to good use. In this context the clustered pilaster, with its suggestion of a half-pilaster, should be mentioned again. The strict tectonic mode had demanded clear forms which were whole and therefore calm. But overlapping forms result in something intangible and are therefore a stimulus to movement. If, in addition to this partial overlapping, the composition is complex and the forms and motifs bewilderingly profuse, so that the individual part, however large, loses its significance

in the mass effect, then there are the elements that produce that impression of overwhelming and intoxicating lavishness peculiar to the baroque style.

Let us take as an example the ceiling of the Galleria Farnese by the brothers Carracci (pl. 2). Although it derives from Michelangelo's Sistine ceiling, the difference is immense. Michelangelo's clear, architectonic arrangement has been sacrificed in order to achieve a richness beyond one's full comprehension. The principles of the design are difficult to recognise and in the face of this intangibility the eye remains perpetually in a state of unrest. Image overlaps image, and it seems as if removing one will only reveal another; the corners open out into unending vistas.

The same principles of design govern the magnificent façade of St. Peter's (pl. 7) and of its imitators. Again the masses of interpenetrating and overlapping forms make it impossible to distinguish the actual space-enclosing wall. This very antipathy to any form with a clear contour is perhaps the most basic trait of the baroque style.

The church interior, its greatest achievement, revealed a completely new *conception of space directed towards infinity:* form is dissolved in favour of the *magic spell of light* – the highest manifestation of the painterly. No longer was the aim one of fixed spatial proportions and self-contained spaces with their satisfying relationships between height, breadth and depth. The painterly style thought first of the effects of light: the unfathomableness of a dark depth, the magic of light streaming down from the invisible height of a dome, the transition from dark to light and lighter still are the elements with which it worked.

The space of the interior, evenly lit in the Renaissance and conceived as a structurally closed entity, seemed in the baroque to go on indefinitely. The enclosing shell of the building hardly counted: in all directions one's gaze is drawn into infinity. The end of the choir disappears in the

gold and glimmer of the towering high altar, in the gleam of the 'splendori celesti', while the dark chapels of the nave are hardly recognisable; above, instead of the flat ceiling which had calmly closed off the space, loomed a huge barrel-vault. It too seems open: clouds stream down with choirs of angels and all the glory of heaven; our eyes and minds are lost in immeasurable space.

True, these effects of an all-consuming decoration are the product of a later period of baroque, but the determining feature of this art, the uncontrolled revelling in space and light, was strongly felt from the first. The contrast between this attitude and the Renaissance is, of course, no more than relative, for the earlier period had not quite been able to resist the charm of light effects. But we are inclined to see things in a more painterly way than the Renaissance did, more so than was intended. Our point of view should be that a feeling for effects of light cannot exist as long as it is not desired by current taste.

Conclusion: the system of proportionality

Quite early in the Renaissance the theory was formulated that the sign of perfection in a work of art was that it could not be changed, not even in the smallest detail, without destroying the beauty and the meaning of the whole. That this rule was formally recognised as early as the mid-fifteenth century is perhaps the most significant factor in the development of Italian art towards the classical ideal. Its formulator was the great Leon Battista Alberti.

The classic passage from his *De re aedificatoria*[12] reads as follows:

'Nos tamen sic deffiniemus: ut sit pulchritudo certa cum ratione concinnitas universarum partium in eo cujus sint: ita ut addi aut diminui aut immutari possit nihil quin improbabilius reddat. Magnum hoc et divinum . . .' ['. . . I

shall define beauty to be a harmony of all the parts, in whatsoever subject it appears, fitted together with such proportion and connection, that nothing could be added, diminished or altered, but for the worse. A quality . . . noble and divine. . . .']¹³

Alberti is here a prophet, for his conceptions were fulfilled a half century later by Raphael and Bramante.

If we ask how this effect was to be attained in architecture, the answer is, almost entirely by harmony of proportions. The proportions of the whole and of the parts must be based on an underlying unity; none must appear accidental and each must follow from the other as a matter of necessity, as the only possible and natural one. This kind of interconnection is rightly called organic, for its secret lies in the very fact that art works like nature, *that the image of the whole is repeated in its parts*. Let us, as a concrete example of this, look at the top storey of the Cancelleria (fig. 9). The small

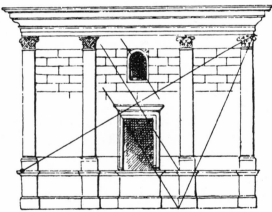

Fig. 9 Proportional system of the Cancelleria

window at the top has the same proportions as the main one, and this in turn only repeats the proportions of the bay which it occupies. Further, the area of the whole order is fixed according to the same ratio, but inverted (b:h =

H:B), so that the diagonals are at right angles to each other. This determines the proportions of the side bays, and they again echo the form of the entire wing of three storeys, excluding, of course, the base and cornice. Astonishing as this all-embracing harmony may be, it extends much further, for not even the smallest detail is allowed to escape the basic ratio; and this, finally, far from being arbitrary, is determined by the golden section, a proportion which we experience as 'pure', that is, as completely satisfying and therefore completely natural.

What we term proportionality, Alberti calls *finitio*.[14] His definition of this word is: 'correspondentia quaedam linearum inter se, quibus quantitates (of length, breadth and depth) dimetiantur'; this, admittedly, does not say very much. In the sixth book, on the other hand, the words 'omnia ad certos angulos paribus lineis adaequanda' are probably intended to signify the same as the theory formulated above. *Finitio* is a constituent element of the highest concept of all, that of *'concinnitas'*. Basically, however, both these terms mean the same thing, or at any rate Alberti uses them interchangeably to mean complete harmony. 'Concinnitas' means that the separate parts 'mutuo ad speciem correspondeant'. Elsewhere it is 'consensus et conspiratio partium', and when he speaks of a beautiful façade as 'musica', in which not a note can be changed, he means nothing else than the unalterable, or the organic determination of form.[15]

These terms are quite alien to the baroque, and it is inevitable that they should be; the aim of this style is not to represent a perfected state, but to suggest an incomplete process and a movement towards its completion. This is why the formal relationships become looser, for the baroque is bold enough to turn the harmony into a dissonance by using imperfect proportions. As long as a work is to have any aesthetic meaning at all, its proportions cannot of course be

governed entirely by such a dissonance. But harmoniously related proportions became fewer and less conspicuous. The simple harmonies of Bramante's style suddenly seemed trivial and made way for more far-fetched relationships, more unnatural transitions that the untrained eye could easily mistake for complete absence of form. Consider especially the consequences of devices such as superimposed pilasters, blurred contours, and in short, the abolition, of all clearly separated elements. In Giacomo della Porta's Gesù façade (fig. 16) the rectangle of the main doorway, plus the segmental pediment, with pilasters, base and entablature, has, as we should expect, the same proportions as the entire central section of the façade: that is, the area covered by the main pediment excluding the base of the lower order of pilasters. But the ratio is obscured by the insertion of another pediment and half-columns into the segmental pediments with the pilasters; this detracts from the authority of the pilaster order through its columns and sets itself up as the more important of the two orders. Motifs of this kind occur several times over on the façade. The analogy with certain effects in advanced musical composition need not be stressed.

The significant thing is not the attempt to complicate our perception of harmonious relationships, but the intention to create an intentional dissonance. The baroque flaunts cramped niches, windows disproportionate to their allotted space, and paintings much too large for the surfaces they fill[16]; they are transposed from a different key, tuned to a different scale of proportions. The aesthetic charm of this approach is the resolution of the discords. Towards the top the discordant elements come to terms and a harmony of pure relationships is created. Such relationships go as far as contrasting an interior with an exterior, the vestibule with the library in the Laurenziana (pls. 1 and 2), the vestibule with the courtyard in the Palazzo Farnese (fig. 10

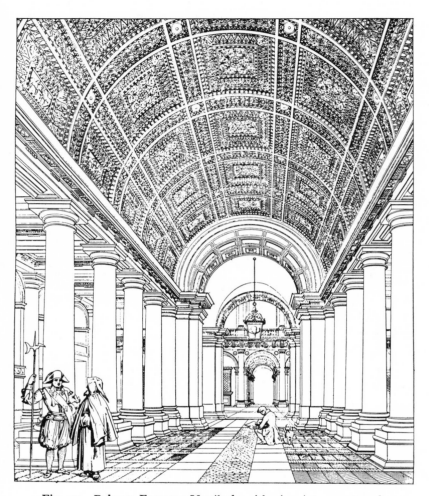

Fig. 10 Palazzo Farnese: Vestibule with view into courtyard

and pl. 17). Architecture had become dramatic; the work of art was no longer composed of a series of independently beautiful and self-contained parts. Only through the whole could the individual part gain value and meaning, or a satisfying conclusion and a termination be brought about.

The art of the Renaissance strove for perfection, 'something that nature can only achieve rarely'. The effectiveness of baroque depends on the stimulating quality of a formlessness which first has to be overcome. Alberti's 'concinnitas' is in the last resort at one with the spirit of nature[17], the creator and greatest of all artists (optima artifex). The art of man only tries to enter into the cohesiveness of natural creation and thereby into that universal harmony which finds such repeated and enthusiastic expression in Alberti's writing. Nature is consistent in all its parts: 'Certissimum est naturam in omnibus sui esse persimilem.'

I believe that here we have a glimpse into the very heart of the artistic spirit of the Renaissance, and at the same time a point of view for the clearest comprehension of the change to the baroque style.

Part II

THE CAUSES OF THE CHANGE IN STYLE

THE CAUSES OF THE CHANGE IN STYLE

Where are the sources of the baroque? In one's astonishment at this great phenomenon, appearing like a natural force, irresistibly carrying all before it, one is bound to seek an origin and a cause. Why did the Renaissance come to an end? Why was it followed, particularly, by baroque?

The change seems an inevitable one. It is inconceivable that this style originated at the will of one man seeking satisfaction through something that had never existed before. It was not a matter of experiments by individual architects, each of them exploring in a different direction, but rather of a *style* of which the most essential characteristic was the universality of its sense of form. We can see the new movement beginning at many different points: here and there the old style began to change and gradually more and more was gripped by change, until nothing could resist its force. With this the new style had come into being. Why did it happen in this way?

One possible answer is the theory of *blunted sensibility*, commonly offered in the past. It suggests that the forms of the Renaissance had ceased to exert their charm, so that the too-often-seen was no longer effective and that jaded sensibilities demanded a more powerful impact. Architecture changed in order to supply this demand and thus became baroque.

This theory is opposed by another, which sees the history of style as a reflection of changes in the pattern of human life. According to this hypothesis, style is an *expression* of its

age, and changes with the changes in human sensibility. The Renaissance had to die because it no longer responded to the pulse of the age; it no longer expressed the ideas that governed the age or appeared most vital to it.

In the first theory, formal development is totally independent of its temporal context. The progress from hard to soft and from straight to curved is purely mechanical, so to speak; the sharp, angular forms soften under the artist's hands as if of their own accord. The style unravels, lives itself out, or what you will. The best analogy for this process is that of a plant blossoming and withering. Thus, the Renaissance could no more go on without changing than a flower can bloom without withering. It is no fault of the soil that the plant dies: the plant carries with it the laws of its own existence. And so it is with style; the necessity for change comes not from without but from within and formal sensibility develops according to its own laws. The basic assumption of this theory is correct. It is quite true that the organs of perception are numbed by an effect which is too often repeated. Our emphatic response to this effect become less intensive, forms lose their power to impress because they no longer invoke this response; they are played out and lose their expressiveness. This diminished empathy could be called a 'jaded formal response'. It seems doubtful that this process is due entirely to a 'clearer memorised image', as Adolf Göller would have us believe,[1] but it is feasible that this jaded response should necessitate more powerful effects.

This theory, however, does little to explain the baroque style. It is unconvincing for two reasons. The first is that it is one-sided; man is regarded purely as a form-experiencing creature, enjoying, tiring, demanding fresh stimuli, not as a real and vital being. Yet an action or experience not conditioned by our general responses to life, our personality and our whole being, is inconceivable. If, therefore, the baroque style sometimes had recourse to extravagantly powerful

effects, the reason is rather a reaction to a general numbing of the nerves, and not to a jaded formal perceptiveness. It is not because Bramante's forms had ceased to excite the imagination that architecture had to resort to more forceful expressive means, but because of a universal loss of refined perceptiveness caused by a high degree of emotional indulgence, which rendered all less obtrusive stimuli ineffective.[2] But can this phenomenon work in favour of the formation of a style? What kind of enhancement does it require? To increase the size, the slenderness or the degree of animation of a thing, or to invent ever more complicated combinations, does not in itself engender something basically new. Although Gothic art developed in the direction of ever slimmer and more pointed shapes, to a point of extreme exaggeration; although it is possible to invent the most complicated proportional system or the most artful combinations of forms, it remains doubtful how such developments can lead to a new style.[3] The baroque style, however, is something completely new; it cannot be deduced from what went before. The separate devices used to counter this dulled sensibility – for instance, the less easily comprehended proportional system, do not constitute the *essence* of the new style. Why do the forms of art become heavy and massive; why not light and playful? There must be a different explanation; this one is insufficient.

The hypothesis put forward by Professor Göller seems hardly tenable. The 'jading of formal sensibility' to him is but 'the driving force to which we owe the progress in art since the primitive decorations of the earliest peoples'. Its cause is 'the sharpening of the memory image'. Since 'the mental effort needed to create the memory of a beautiful form' is supposed to consist in 'the unconscious spiritual pleasure generated by this form', this hypothesis indeed stipulates a state of constant change; for as soon as we have memorised the forms, they lose all their attraction for

us. The task of the architect then, is constantly to produce something novel by varying the grouping of masses, the shape and combination of individual forms. But how, then, does a consistent formal approach, a style, come into being? Why, for instance, did not everyone at the end of the Renaissance experiment in a different direction? Is the answer that only one was acceptable, and if so, why?

The psychological approach has also been used to explain the new formal conception that comes with baroque. According to this point of view the formal style is the expression of its age; it is not a new approach, but one which has never been systematically founded. The technical side of the profession has always opposed it, sometimes with reason, for the so-called 'kultur-historisch' introductions in textbooks contain a good deal that is ridiculous, summarising long periods of time under concepts of a very general kind which in turn are made to account for the conditions of public and private, intellectual and spiritual life. They present us with a pale image of the whole, and leave us at a loss to find the threads which are supposed to join these general facts to the style in question. We are given no clue to the relationship between the artist's personal fantasies and the contemporary background. What has Gothic to do with the feudal system or with scholasticism? What bridge connects Jesuitism with the baroque? Can we be satisfied with comparisons with a vague movement towards an end that totally disregard the means? Is there aesthetic significance in the fact that the Jesuits forced their spiritual system on the individual and made him sacrifice his rights to the idea of the whole?

Before we indulge in comparisons of this kind, we must first ask what can be expressed by means of architecture at all, and what are the factors which influence artistic imagination. A few indications must suffice, no systematic investigation can be undertaken here.[4] What, first of all, determines the artist's creative attitude to form? It has been

said to be the character of the age he lives in; for the Gothic period, for instance, feudalism, scholasticism, the life of the spirit. But, we still have to find the path that leads from the cell of the scholar to the mason's yard. In fact little is gained by enumerating such general cultural forces, even if we may with delicate perceptiveness discover some tendencies similar to the current style in retrospect. What matter are not the individual products of an age, but the fundamental temper which produced them. This in turn, cannot be contained in a particular idea or system; if it were, it would not be what it is, a temper or a mood. Ideas can only be explicitly stated, but moods can also be conveyed with architectural forms; at any rate, every style imparts a more or less definite mood. We must only determine what kind of expressive means a style commands. To do this we must proceed from a psychological fact which is both familiar and easily checked. We judge every object by analogy with our own bodies. The object – even if completely dissimilar to ourselves – will not only transform itself immediately into a creature, with head and foot, back and front; and not only are we convinced that this creature must feel ill at ease if it does not stand upright and seems about to fall over, but we go so far as to experience, to a highly sensitive degree, the spiritual condition and contentment or discontent expressed by any configuration, however different from ourselves. We can comprehend the dumb, imprisoned existence of a bulky, memberless, amorphous conglomeration, heavy and immovable, as easily as the fine and clear disposition of something delicate and lightly articulated.

We always project a corporeal state conforming to our own; we interpret the whole outside world according to the expressive system with which we have become familiar from our own bodies. That which we have experienced in ourselves as the expression of severe strictness, taut self-discipline or uncontrolled heavy relaxation, we transfer to all other bodies.[5]

Now it is very unlikely that architecture should not participate in this process of unconscious endowment of animation: indeed it does so in the greatest possible measure. Moreover, it is clear that architecture, an art of corporeal masses, can relate only to man as a corporeal being. It is an expression of its time in so far as it reflects the corporeal essence of man and his particular habits of deportment and movement, it does not matter whether they are light and playful, or solemn and grave, or whether his attitude to life is agitated or calm; in a word, architecture expresses the 'Lebensgefühl'[6] of an epoch. As an art, however, it will give an ideal enhancement of this 'Lebensgefühl'; in other words, it will express man's aspirations.

It is self-evident that a style can only be born when there is a strong receptivity for a certain kind of corporeal presence. This is a quality which is totally absent in our own age; but there is, on the other hand, a Gothic deportment, with its tense muscles and precise movements; everything is sharp and precisely pointed, there is no relaxation, no flabbiness, a will is expressed everywhere in the most explicit fashion. The Gothic nose is fine and thin. Every massive shape, everything broad and calm has disappeared. The body sublimates itself completely in energy. Figures are slim and extended, and appear as it were to be on tiptoe. The Renaissance, by contrast, evolves the expression of a present state of well-being in which the hard frozen forms become loosened and liberated and all is pervaded by vigour, both in its movement and its static calm.

The most immediate formal expression of a chosen form of deportment and movement is by means of costume. We have only to compare a gothic shoe with a Renaissance one to see that each conveys a completely different way of stepping; the one is narrow and elongated and ends in a long point; the other is broad and comfortable and treads the ground with quiet assurance.

I have of course no intention of denying that individual architectural forms may originate with technical causes. Forms have certainly always been influenced to a certain extent by the nature of the material, the methods of working it, and techniques of construction. But I shall maintain, particularly in face of certain recent theories, that technical factors cannot create a style; that the word art always implies primarily a particular conception of form. The forms which result from technical necessity must not be allowed to contradict this conception; they can only endure if they fit into a formal taste already previously established. Nor, in my opinion, is a style a uniformly accurate mirror of its time throughout its evolution. I am thinking not so much of the early periods of history, when style was still at odds with expression and only gradually becoming articulate, as of those periods when a fully developed formal language was transmitted from one race to another; when the style, having become hardened and exhausted by uncomprehending misuse, turns more and more into a lifeless scheme. When this happens the temper of a people must be gauged not in the heavy and ponderous forms of architecture, but in the less monumental decorative arts; it is in them that formal sensibility finds an immediate and unchecked outlet, and in them that the renewal takes place. A new style, in fact, is always born within the sphere of the decorative arts.

To *explain* a style then can mean nothing other than to place it in its general historical context and to verify that it speaks in harmony with the other organs of its age. The point of departure for our investigation of the origins of baroque will therefore be the most analogous comparison, that of the conception and representation of the human figure in the representational arts, rather than a general 'kultur-historisch' sketch of the post-Renaissance; and the point of comparison will be the general type of appearance

rather than the individual motifs. Whether a complete characterisation of a style can be obtained in this way is another problem, with which I shall not deal here. But the significance of reducing stylistic forms into terms of the *human body* is that it provides us with an immediate expression of the spiritual.

We can therefore describe the corporeal ideal of Roman baroque in the following terms: the slender, well-articulated figures of the Renaissance have been replaced by massive bodies, large, awkward, with bulging muscles and swirling draperies (the herculean). The light-heartedness and resilience of the Renaissance have disappeared; all forms have become weightier and press more heavily on the ground. To recline is to lie, heavy and immobile, completely without tension.

While the Renaissance permeated the whole body with its feeling, and closely-enveloping draperies exposed its contours everywhere, the baroque luxuriated in unarticulated mass. One is more aware of the matter than the structure of the body and its articulation. Flesh is less solid, softer and flabbier than the taut muscles of the Renaissance figure. Limbs are not loosened, not free or mobile, but awkward and imprisoned; the figures do not progress beyond a state of mute compactness.

But this is only one aspect, for massiveness is complemented everywhere by violent and impetuous movement; in fact, art is exclusively concerned with the representation of the animated.

This movement became ever faster and more hasty. Three representations of the Ascension will make this clear. In Titian's picture Christ is gently lifted upwards, in Correggio's He rushes heavenwards, while Agostino Carracci makes Him almost shoot up to Heaven. The ideal state has changed from one of calm fulfilment to restless animation. There must be violent agitation everywhere. Every simple

utterance, previously expressed with ease and vigour, is now accompanied by passionate effort. A quiet stance becomes full of pathos and movement; figures rear themselves up as if an enormous effort were necessary to prevent them from collapse. How characteristic is the transformation of Michelangelo's Slaves into those of the Carracci in the Galleria Farnese! What restlessness, what contortions! Any voluntary movement is ponderous and laborious, and demands an enormous energy. At the same time, the limbs no longer move independently; the rest of the body is also drawn partially into the movement.

This emotion of wild, ecstatic delight cannot be expressed uniformly by the whole body: emotion breaks out with violence in certain organs, while the rest of the body remains subject only to gravity. But this enormous expenditure of effort is not a sign of greater strength. On the contrary: the movement of voluntary organs is deficient; the mental impulses are far from completely controlling the movements of the body. The two elements, mind and body, have, as it were, parted company. It is as if these men no longer have full power over their own bodies, no longer permeate them with their own will; animation and formal articulateness are not equally distributed. To create dissolution, an impression of having been poured, of yielding, of amorphousness, yet leaving certain parts in violent movement; this became the exclusive ideal of art.

As an example we may compare the Galatea of Raphael in the Farnesina with Agostino Carracci's interpretation of her in the Palazzo Farnese; the example is modestly chosen but is perfectly characteristic. Carracci's is more fervent, more vital, but how remote is her body from the light stance of Raphael's! How heavy she is, without poise, leaning on her companion and abandoning herself totally to the weight of her own body![7]

If the body by itself cannot express sufficient massiveness

heavy draperies are used to make the contrast between agitated movement and dead weight more compelling.

This is how the ideal of the human figure developed in Rome after the Renaissance.[8] The parallels with architectural forms are not difficult to see: the massiveness, the enormous weight, the lack of formal discipline and thorough-going articulation, the increased animation, the restlessness, the violent agitation: in both cases the symptoms are identical. The parallel development continues when towards the middle of the seventeenth century, the weight as it were lifts, and architectural forms become lighter again. We, however, are no longer concerned with this period.

If the fate of art in general can be said to rest in the hands of a single man, then the origins of this new art may be traced to none other than *Michelangelo*. Michelangelo is justly called the father of baroque; this is not because of his eccentricities, since eccentricity cannot be the guiding principle of a style, but because he treated forms with a violence, a terrible seriousness which could only find expression in formlessness. His contemporaries called this quality 'terribilità'.

I should like to describe the increasing idiosyncrasy of Michelangelo's later works by repeating some remarks from Anton Springers characterisation: '(His) figures are much more powerful than real ones and, whereas in ancient art all actions are the expressions of free-will and can be retracted at any moment, Michelangelo's men and women appear to be the unresisting victims of an inner compulsion, animating the individual members, not harmoniously and uniformly, but fitfully, so that some are expressive to the utmost while others are almost totally lifeless and inert.'[9] And again. 'Vitality is unevenly distributed', 'some parts are superhuman in their strength, others all weight'. His figures are massive, sometimes herculean. The feeling of restlessness is enhanced by unconsidering confrontation of

corresponding limbs (*contrapposto*). Although these figures are in a state of violent emotion, their movements are inhibited, only breaking forth at certain points through their mute massiveness, but there all the more violently and passionately. Jacob Burckhardt declares that some of Michelangelo's figures seem at first sight to be chastened monsters rather than elevated human beings.[10]

In the Medici tombs in S. Lorenzo we recognise the climax of this art. Here also we find the most explicit expression of the mood in whose service this kind of art exists. There is no need to pay too close attention either to the allegories that the figures personify, nor to their surroundings. These figures of Night and Day, Evening and Morning, as they lie, sighing silently, ridding their limbs of sleep, drawing them in convulsively or letting them hang lifelessly, are possessed by a deep inner restlessness and discontent, a mood found constantly in Michelangelo's work, in his poetry as well as his representation of figures,[11] and which one would be tempted sometimes to call 'Weltschmerz', had not this word lost its force.

We marvel as if at a miracle that Michelangelo could force his moods into sculpture and painting; perhaps it is more miraculous that he could do so with architecture. His buildings display his most distinctive personality everywhere, as those of no other artist do. The personal mood has a forcefulness and clarity hitherto unknown in architecture and never to be achieved again.

The art of Michelangelo never embodies the happiness of human existence, and for this reason alone it transcends the art of the Renaissance. The atmosphere of the post-Renaissance period is fundamentally solemn. This solemnity was brought to bear in all spheres of life: religious conscience, a renewed distinction between the worldly and the ecclesiastical, the ceasing of the uninhibited enjoyment of life Tasso chose for his Christian epic, *Gerusalemme Liberata*, a

hero who is weary of the world.[12] In social intercourse the general tone became formal and solemn; the light and easy grace of the Renaissance gave way to seriousness and dignity, the gay playfulness to pompous, rustling splendour. Grandeur and importance became the only standards.

It is interesting to observe how the new style also took hold of poetry. The difference of language between Ariosto's *Orlando Furioso* (1516) and Tasso's *Gerusalemme Liberata* (1584) reveal the change of mood. How simple, how cheerful and lively are the first lines of the Orlando:

> *Le donne, i cavalier, l'arme, gli amori,*
> *Le cortesie, l'audaci imprese io canto,*
> *Che furo al tempo, che passaro i Mori*
> *D'Africa il mare, e in Francia nocquer tanto;* . . .[13]

How very different Tasso's opening lines:

> *Canto l'armi pietose, e il Capitano*
> *Che il gran sepolcro liberò di Cristo:*
> *Molto egli oprò col senno e con la mano;*
> *Molto soffrì nel glorioso acquisto:*
> *E invan l'inferno a lui s'oppose, e invano*
> *S'armò d'Asia e di Libia il popol misto;*
> *Che il Ciel gli diè favore* . . .[14]

Note everywhere the lofty adjectives, the resounding line-endings, the measured repetitions (molto —, molto —, e invano — e invano); the weighty sentence construction, and the slower general rhythm. But the grandeur is not only in the expression; the verbal images also become larger. How significant, for instance, is Tasso's transformation of the Muses. He lifts them into a vague heavenly zone and crowns them, not with a laurel wreath, but with 'a golden crown of everlasting stars'.[15] The adjective 'gran' is liberally used, and visions of grandeur must be conjured up everywhere.

It is fascinating to detect this new mood only halfway through the century in Berni's transcription of Boiardo's

Orlando innamorato, written about fifty years after the original.[16] When Boiardo writes 'To Angelica shines the morning star, the lily in the garden, the rose', Berni changes it to this: 'To Angelica shines the bright star in the east, yes, to be true, it is the sun.' The image is larger, more unified and more resonant. Boiardo concentrates too much on details and particulars; he is still in love with the gay variety of the early Renaissance. The later period yearned for grandeur.

We might conclude in general terms that in the Renaissance every detail was given loving attention for its own sake, that it was impossible to lavish too much care on invention in variety or on the execution of the particular. Now, however, we step further back and survey the general effect; we do not require grandeur in the individual part, but only a general impression; there is *less perception* and *more atmosphere*.

We have now evidently reached a point beyond that to which an analysis of the baroque conception of the human body would have brought us. In fact an important characteristic of the baroque style is that it cannot be seen in terms of the human body. The baroque has no sense of the significance of individual forms, only for the more muted effect of the whole. The individual, defined and plastic form has ceased to matter; compositions are in the mass effects of light and shade and the most indefinite of all elements have become the real means of expression. Baroque, that is, lacks the wonderful intimacy of empathic response to every single form which was characteristic of the Renaissance. It does not feel the architectural body in the sense of following sympathetically the function of each member; rather it keeps only to the painterly image of the whole. The effect of light assumes a greater significance than the form.

I decline to explain how the power to feel a form dimin-

ished. It seems to be conditioned by several factors; the most important may be the increasing interest in 'atmosphere' in the modern sense of the word. This would have threatened the 'good' style in two ways. On the one hand the cult of the atmospheric would have damaged the empathic response to the human body, and on the other it would have forced architecture into unfavourable competition with painting, whose expressive means are actually designed to convey this elusive quality. This is why painting has become the modern art-form specifically: it offers the directest vehicle of expression to the contemporary idiom.

Yet for the spirit of baroque architecture was indispensable; it alone possessed the unique power to translate grandeur and loftiness into visible terms. Here we hit the nerve-centre of baroque: it is only able to manifest itself on a grand scale. It is therefore in the church alone that it finds full expression: the pathos of the post-classical period is in the desire to be sublimated in the infinite, in the feeling of overwhelmingness and unfathomableness. The comprehensible is refused, the imagination demands to be overpowered. It is a kind of intoxication with which baroque architecture fills us, particularly the huge church interiors. We are consumed by an all-embracing sensation of heaviness, helpless to grasp anything, wishing to yield totally to the infinite.

The new religious fervour kindled by the Jesuits finds a perfect outlet in the contemplation of the infinite heavens and countless angel choirs.[17] It revels in imagining the unimaginable, it plunges with ecstasy into the abyss of infinity. This uncontrolled enthusiasm is not, however, confined to the Jesuits; not only did Giordano Bruno experience similar ecstasies – for him the highest bliss was to be consumed by the All – but the Jesuits took over an attitude that had been prepared long beforehand. The first signs of an extreme sensibility are visible even in the last years of Raphael. His S. Cecilia, painted in 1513, with her drooping

arms and her face raised mutely, unseeing, in complete abandonment to the heavenly strains, was the first in the long line of pictures which reiterate the same sensations in ever more compelling form, sensuous, abandoned and ecstatic, yearning for self-surrender and divine rapture.

This mystical yearning could not be satisfied by the simple, well-defined and easily comprehended form. Our half-closed eyes no longer see the beauties of a line, we demand vaguer effects. The ideals of the new art are unlimited space and the elusive magic of light.

Carl Justi's description of Piranesi as a 'modern, passionate nature', whose 'sphere is the infinite, the mystery of the sublime, of space, of energy,' has a more general application.[18]

One can hardly fail to recognise the affinity that our own age in particular bears to the Italian baroque. A *Richard Wagner* appeals to the same emotions: 'Ertrinken – versinken – unbewusst – hoechste Lust!' His conception of art shows a complete correspondence with those of the baroque and it is not by coincidence that Wagner harks back to Palestrina:[19] *Palestrina* is the contemporary of the baroque style.

We are not accustomed to think of Palestrina's music as baroque, but a comparative stylistic analysis will reveal the affinities. Nevertheless, at the point where the one art begins to decline, the other finds its real nature. What is considered a fault and an offence to the sensibilities in architecture may be perfectly acceptable in music, since it is the nature of music to express moods that have no form. Indeed, the restraining of the finished and rhythmic phrase, the strict, systematic construction and the transparently clear articulation which may be fitting and even necessary to express a mood in music, signify in architecture that its natural limits have been transgressed. Thus the vital element in Palestrina's music – the 'latent rhythm', the adoption of the 'a-

rhythmic',[20] is hailed as progress; for architecture it spells dissolution. Its flowering depends on a general felicity of form and boundary. The Renaissance possessed this. The greatest beauty 'concinnitas' is, in the words of Alberti, 'animi rationisque consors'; it is a state of perfection, the goal towards which nature strives in all her manifestations.[21] We are immediately conscious of a perfect object for our nature craves it: 'natura enim optima concupiscimus et optimis cum voluptate adhaeremus'.

Perfection is the exact mean between excess and deficiency. But the formless art knows no such limits, no consummation or finality.

The classical period of the Renaissance shares the perception of classical antiquity. Conversely there is no clearer way of characterising the universal antithesis of baroque than to quote Carl Justi's characterisation of a mind keyed to the classical ideal, that of Winckelmann:[22] 'Moderation and form, simplicity and noble line, stillness of soul and gentleness of sensibility: these were the main tenets of his creed. His favourite symbol was crystal-clear water.'

If we were to take the opposite of each of these concepts, we should have the substance of the new style.

Part III

THE DEVELOPMENT OF THE BAROQUE TYPES

I. THE CHURCH

The ideal type of the Renaissance church was central in plan and surmounted by a dome. In this form the age found its most perfect expression, concentrating here its finest energies. More than any longitudinal building, the centrally planned building was the embodiment of complete unity and self-sufficiency. The correspondence between exterior and interior is complete and the aspect presented by the building from each side is identical. Every line, inside and outside, seems to be conditioned by one central regularising and unifying force, and it is this that accounts for the static and restful quality characteristic of buildings of this kind. The four arms of the cross are in balance, undisturbed and unmoving; the light from the dome is distributed equally to all parts of the building. A state of fulfilment, of perfect *being*, reigns throughout.

But the ideal of centrality did not last. The new type of longitudinal plan created by Vignola in the Gesù became so influential that even St. Peter's had to yield to it. Whatever liturgical advantages the longitudinal plan may have had, these cannot be sufficient to account for its adoption by the baroque, for these reasons had not, after all, deterred the Renaissance from centralised design.

The explanation must surely be aesthetic. There is even some proof that this was so in the case of the Redentore in Venice, where the question of a centralised or a longitudinal plan was decided on the basis of the Gesù. I should hesitate to use this as evidence were the same phenomena not to be observed wherever one turns: in the decorative arts the

circle is replaced by the oval, the square by the oblong, and so forth. Speaking in psychological terms, the fulfilled and the static is abandoned for the unfulfilled and evolving. There is no desire for perfection, only for tension. The centralised plan is a complete and instantaneous statement of absolute fulfilment, seeking no more than the enjoyment of its present existence, but the longitudinal plan has a definite direction in which it seems constantly to be moving. The combination of the longitudinal church with dome is the most perfect means of suggesting this impression: as the visitor enters he is drawn forwards, as if under a spell, towards the light that streams down from the dome. And the dome itself only comes into being as he advances, growing under his eyes, in the true spirit of baroque.

The difference between the longitudinal movement in a gothic church and that in a baroque one is that in the latter two separate elements are allowed to interact: on the one hand, the nave, ending in the apse, and on the other, the dome, absorbing everything into itself. The nave is short enough for the centralising influence of the dome to be felt everywhere; it is never a mere appendage. The nave hardly measures twice the diameter of the dome, and as it is a unified space with only chapels down the sides, it need be no wider than the dome. The typical example is Vignola's Gesù (1568) (fig. 15).

Symptoms of this change appear already in the work of Bramante who, according to Onophrius Panvinius's *De Basilica Vaticana*, designed a longitudinal project for St. Peter's; whether he did so voluntarily is open to question. Raphael[1] and Antonio da Sangallo also made longitudinal plans. The last works of Michelangelo, S. Giovanni de' Fiorentini and S. Maria degli Angeli, were an influence in the direction of the longitudinal plan; the altered design for St. Peter's was the decisive act. For smaller churches the circular space was replaced by an *oval* one, first found in

Serlio, but this was not a common form. In Rome it appears in Vignola's S. Andrea in Via Flaminia (1552), with an oval cupola surmounting an oblong space; other examples are S. Giacomo degli Incurabili, by Francesco da Volterra, S. Andrea al Quirinale, by Bernini, and S. Carlo alle Quattro Fontane, by Borromini. The pure, centralised church only returned with the second period of baroque, and by then a different spirit reigned. In northern Italy, on the other hand, it was never abandoned, since, as in representational art, the image of things in their stable reality (Existenzbild) persisted in architecture; the forms of 'being' had always to a certain extent been retained.

The system of the façade. A centrally planned building can dispense with a façade; a longitudinal one cannot. In the hands of the baroque architects the façade became a magnificent show-piece, placed in front of a building without any organic relationship whatever with the interior; side views were totally disregarded. In contrast to the Renaissance, which had seen an infinite number of experiments with façades even if most of them remained mere projects, the baroque at once produced a single type of façade that subsequently went through a very clear course of development. It consisted of two storeys, of which the lower was the height of the chapels; the upper, less wide and crowned with a pediment, corresponded to the nave and was often much higher than it. Generally it was flanked by volutes, but in exceptional cases it was the same width as the lower storey. The wall was articulated with pilasters, with five bays in the lower storey and three in the upper, though in a smaller church it might be three to one. The central bay, rather wider than the others, contained the door and an upper window. The others were filled with niches and rectangular recesses.

The type exists in almost schematic purity in the church of S. Spirito in Sassia (fig. 12).[2] Although it is not yet truly

baroque, this church already contains the elements of form and grouping that were soon to announce the arrival of the new style. In very large churches single pilasters were thought insufficient; coupled pilasters, half-pilasters flanking whole ones, double clustered pilasters, and other similar phenomena appeared. Though the column never quite disappeared, it hardly led an active life again until the seventeenth century; then it relinquished its hitherto limited role of flanking the portal and spread once more over the whole façade. It did not become free-standing again for a long time. At first half, or at any rate a quarter, remained engaged; it only emerged entirely in Carlo Rainaldi's S. Maria in Campitelli (1665). From then on it was always backed by a pilaster.

At first the same types of order were used in the articulating pilasters of storeys, later alternation was more normal. A composite order was usually placed over a Corinthian one, or sometimes a Doric. As in late antiquity, the leaf capital was the favourite type, but the massive formation of the leaves was new: a softly-rounded leaf replaced the jagged acanthus[3] from Antonio da Sangallo onwards and occurs in Vignola's *Regola*. Frieze and architrave remained without ornament, but the frieze of the lower order usually carried an inscription, the dedication of the church, often spread quite happily round angels as in S. Ignazio (1636) and S. Ambrogio e Carlo.

The spaces between capitals were filled with garlands or cartouches. The manner of defining a capital zone goes far back into the Renaissance and was originally taken over from Roman triumphal arches. At first it consisted of a mere frame; later it was filled with wreaths or cartouches that gradually became more luxuriant until none of this area was left empty. The decorations, as we shall see, varied from upper to lower storey and from inner to outer bay.

The bays were at first filled with empty niches, rectan-

gular recesses or raised surfaces, but from the 1570's, when the style became severe, round niches were avoided or kept for the freer upper storey, while in the lower they were replaced by rectangular windows: it is interesting here to compare the project for the Gesù by Vignola with that of Giacomo della Porta (figs. 15 and 16). Niches were then invariably encased in aedicula, illustrating one of the most fundamental baroque ideas, that of concentrating all ornamental features towards the top of any form. Instead of being carried by half-columns or pilasters, the pediment, now strongly projecting and richly decorated, rested on generous consoles ending in simple moulded strips or supports. To avoid a strong horizontal, the base-line of the pediment was usually broken, the horizontal accent of the sill toned down with consoles and jambs extending below it; the effect was completed with a light, simple wreath. The niche itself did not gain its effect from concavity; it contained a statue, and the combination of highly-animated figures and rich decorative surrounds formed a rich and spirited composition.

The tablets that went with the niches, perhaps meant to suggest reliefs, as Michelangelo used them in his project for the façade of S. Lorenzo in Florence, followed a similar development on a small scale; they too were given a firmly projecting pediment, light decoration on the base and swelling ornament.

The doorway, which had once been a simple and subordinate feature, came to occupy pride of place on the façade through the introduction of numerous free-standing columns. The whole area was crowned with its own pediment and sometimes even with a compound pediment, triangular and segmented pediments interlocked.

Similarly the upper window occupied a more prominent position, changing from plain oculus to a show-piece with elaborately treated niches.

For a long time the volute remained changeable in its form. The first volutes, on Alberti's façade of S. Maria Novella, were filled in with a lifeless marble inlay, and these had no successors; those on the Duomo in Turin, and on S. Agostino in Rome, make the tentative nature of this motif clear. In Michelangelo's project for the façade of S. Lorenzo, volutes were replaced by colossal statues of *kouroi*. Vignola's volutes were unornamented and had a simple, steeply ascending line, like those by Bramante on the dome of St. Peter's.[4] Sangallo's more lively treatment in S. Spirito (fig. 12) and his project for the façade of St. Peter's was followed by the younger Giacomo della Porta in S. Caterina de' Funari (pl. 3), but in attempting to achieve a closer connection with the main body of the building he added a subsidiary leaf at the top, curling over backwards. Bizarre attempts to unite nave and bay occur in S. Girolamo, by Martino Lunghi the Elder, and, even more so, in S. Maria Traspontina, by Mascherino; in these, the volutes rise from the top of the side bay, as with Vignola, but terminate at the upper end in a scroll surmounted by a female head carrying an ionic capital. This was apparently an attempt to suggest a caryatid, a device which was not used successfully until much later by Martino Lunghi the younger, in the spirited façades of S. Vincenzo ed Anastasio and S. Antonio de' Portogesi; there the problem is solved in a free and spirited manner. Della Porta's Gesù is the norm (fig. 16): the volute is heavy but vital, the downward rolling motion being strongly accentuated in character with the severe style of the building. In S. Susanna Maderna gave the volute the definitive strenuous form of the baroque (pl. 6). Its massive character was later lost; the volute became a concave strut in the churches of Martino Lunghi the Younger and in Fontana's S. Marcello, where it takes the form of palm branches.

The Florentine volute was a small, bipartite form, with

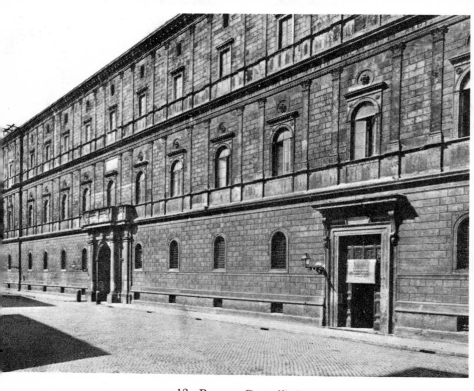

12. Rome: Cancelleria

13. Rome: Palazzo Farnese

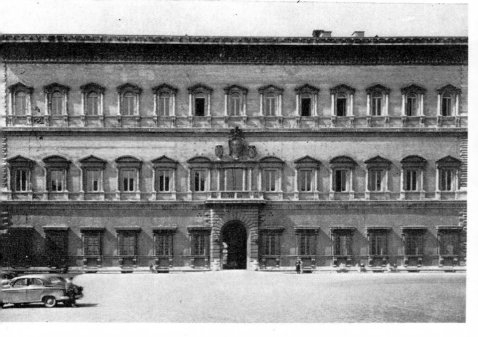

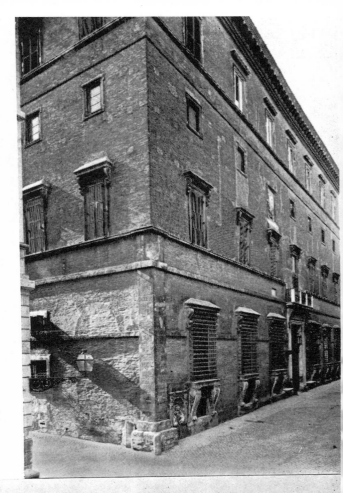

14. Rome:
Palazzo Sacchetti

15. Rome: Palazzo
dei Conservatori

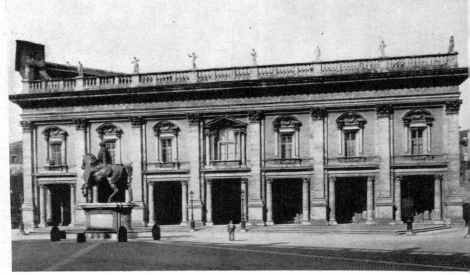

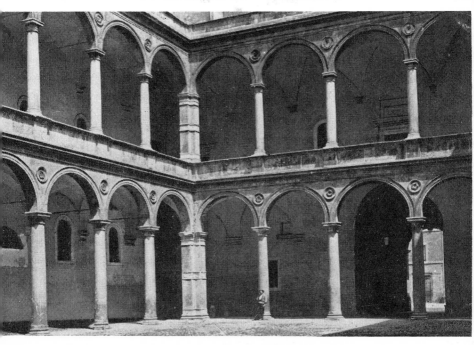

16. Rome: Cancelleria, courtyard

17. Rome: Palazzo Farnese, courtyard

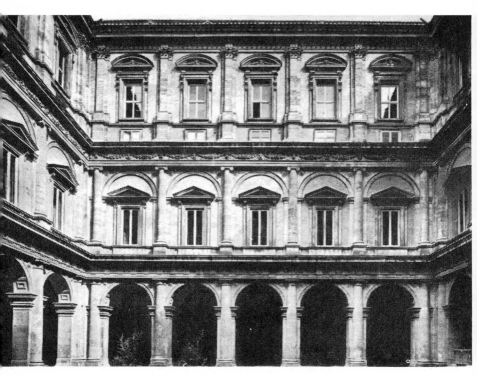

18. Caprarola: Villa Farnese

19. Rome: Vatican, Belvedere Garden
(after a drawing by G. Carpi)

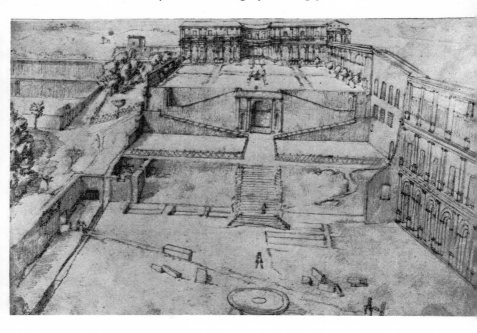

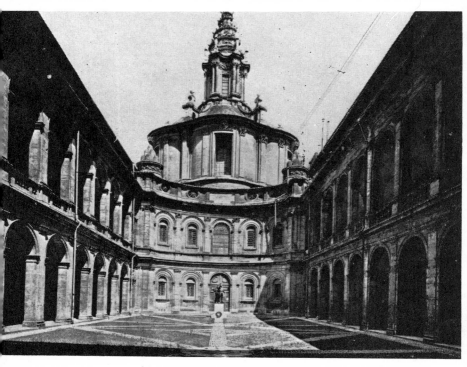

20. Rome: Sapienza, courtyard

21. Frascati: Villa Aldobrandini, *teatro* and fountain

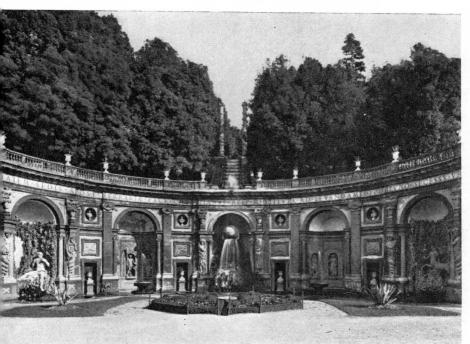

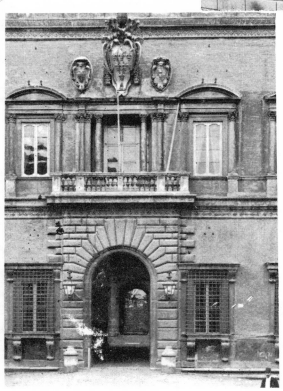

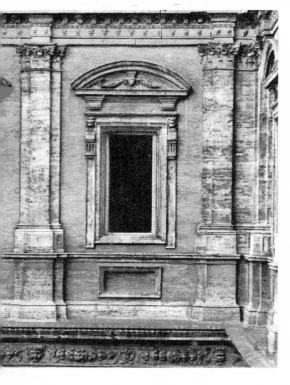

24. Rome: Palazzo Farnese, courtyard, second storey window

22. Rome: Cancelleria, window and coat of arms

23. Rome: Palazzo Farnese, main doorway and coat of arms

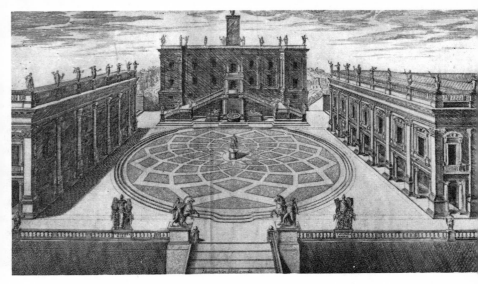

25. Rome: Capitol

26. Rome: Quirinale Palace, Sala Regia

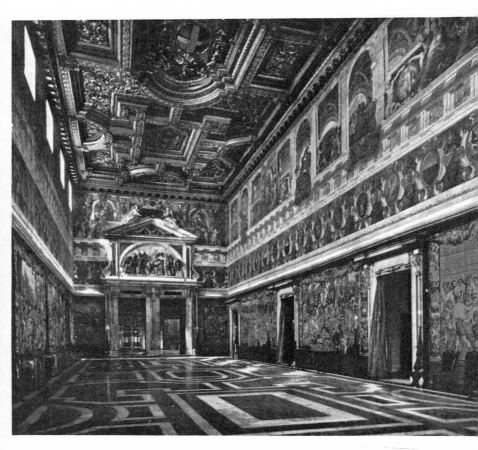

no vitality at all, as can be seen in Nighetti's S. Trinità. The Venetian volute, on the other hand, dissolved into arabesque, even further removed from the Roman baroque (S. Maria degli Scalzi, by Salvi).

In the heavier style the coping of the pediment was given horizontal emphasis with broad *acroteria*. The underlining of individual pilasters with statues, obelisks, candelabra and tripods was never a baroque motif, and while Vignola had intended to have statues on the Gesù, della Porta removed every trace of such forms. Crowning motifs occur in baroque only in such substantial forms as balustrades stretched uniformly across the whole façade, and the balustrade on the façade of S. Susanna is comprehensible and indeed justified only by the answering ones on the walls either side of it.

The steps leading up to a church also became massive and stretched across the whole width of the façade; S. Susanna's are a mistaken modern restoration. Even large flights of steps, like those leading up to S. Gregorio Magno on the top of the Monte Celio (fig. 17), were left quite unarticulated so that the force of the horizontal lines would not be disturbed. The steps themselves were very low, one flight corresponding roughly to the height of the basement, which in the baroque was also always very low. This was in direct contrast to Renaissance theorists like Alberti and Serlio, who prescribed very high basements, since such height gave dignity.

The individual elements in the buildings have now been treated. But however distinctive they may be, they could hardly determine the character of the baroque style by themselves. The decisive factor was the new compositional principle.

The elements of surface decoration were the niche and the tablet, and on the façade of S. Spirito these were so distributed that each niche occupied the exact centre of a bay, with a

tablet at equal intervals above and below, and an agreeable interval on either side (fig. 11). This was the Renaissance conception. The baroque introduced a new rule: the bay was no longer to be a satisfying, self-contained whole. It now seemed that the niches, squeezed between pilasters in spaces apparently too small for them, were forced upwards; unable to remain with any ease in the centre of the bay, they were pushed up against the zone of the capitals and sometimes even penetrated it.

Unless the conflicting elements are somehow resolved, a composition in this manner is restless and disturbing, and resolution does follow in the upper storey. Here the agitation is abated, and both surface and decoration brought into a satisfying relationship.

Corresponding to this vertical progression is a horizontal one. The façade of S. Spirito had five bays of equal weight varied only by a slightly wider centre bay (fig. 12). In the baroque style this system of co-ordination was replaced by an emphatic subordination quite foreign to the Renaissance. The Renaissance façade was also composed of independent and dependent parts, usually in the form of a dominant central section flanked by smaller units at the angles, which were in turn connected to the main body by receding walls. But the parts retained their independence and individuality, in spite of their subordinate position, and were allowed

Fig. 11 S. Spirito in Sassia

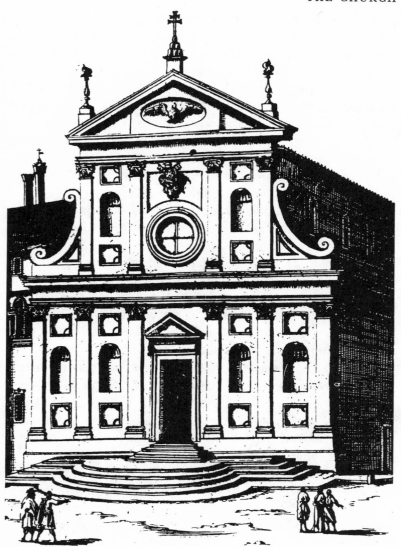

Fig. 12. S. Spirito in Sassia

to develop freely; no line betrayed the fact that they had to submit themselves to a superior force. The baroque could not allow the parts to exist independently; everything remained enclosed in the mass of the whole. A projecting central bay, with less defined side bays behind in graduated layers, gave horizontal articulation. Columns and decorative features, no longer distributed evenly over the whole width of the façade, progressed towards the centre from pilasters to half-columns, and from half-columns to three-quarter-columns; the outside bays remained empty and the centre offered the most decoration and splendour.

Once we have added the taste for the colossal, we have more or less covered the rules which govern the design of the baroque façade; through these Rome and the whole of Italy could soon leave the Renaissance behind them.

But in the second baroque period the feeling for horizontal and vertical accentuation was lost and decoration spread across the whole façade, even as early as 1665 in S. Andrea della Valle. In northern Italy, particularly in Venice, the baroque ideas were never understood.

The baroque was not interested in an organic articulation of the body of the church. The sides of the building were completely neglected, not even faced. All effort was concentrated on the head, and the other limbs were barely indicated. For the side walls, brick was used instead of travertine; chapel windows were framed only with paltry strips, and later even these were omitted. The volutes that had once echoed the façade motif on the clerestory also disappeared. All this is clear in the twin churches of S. Maria dei Miracoli and S. Maria del Monte, at the entrance to the Corso.

It follows that the church precincts also had to be limited to the area in front of the façade. The designs of Bramante's central buildings had provided for completely encircling structures, like the magnificent framing porticoes he had

intended for St. Peter's. The baroque, unconcerned with architectural bodies, wished to distract attention from the sides of the building; what is hidden by the façade must remain unsuspected. On the other hand, the façade itself

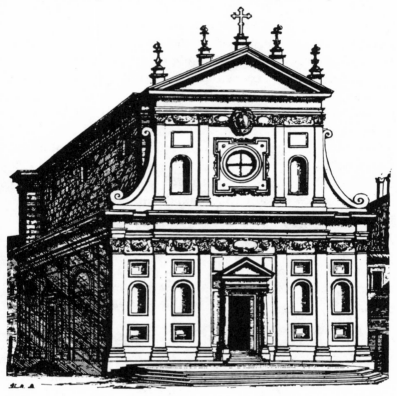

Fig. 13. S. Caterina de' Funari

must have as large a precinct as possible. The baroque demands space, as Bernini's colonnade makes clear.

The historical development of the church façade. We have said that the façade of *S. Spirito* was, so to speak, the schema for all later façades. Everything was still in embryo, and no

particular solution was attempted: lower and upper orders were identical, the central bay flush with the rest of the façade, the cornice static and unbroken (fig. 12).

In *S. Caterina de' Funari*, the earliest work of Giacomo della Porta, the new spirit is present, though still discreet and tentative. The pilasters are still of the same order in both storeys, but the decoration of the bays is already varied: the lower storey is cramped, while the upper breathes more freely. The spaces between capitals are filled with opulent garlands. The horizontal articulation consists of three projecting centre bays with entablature, and angle pilasters. The doorway, with free-standing columns, is already more prominent. The general impression is still one of timid elegance (pl. 3).[5]

The Gesù in Rome was the first building that della Porta was allowed to execute as Vignola's successor (fig. 12), and

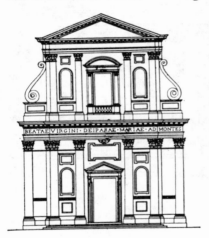

Fig. 14. S. Maria ai Monti Façade

the changes he made to his predecessor's plan are of the greatest interest for the growth of the new style. But first one must mention the small façade of *S. Maria ai Monti*, which, though later than the Gesù and completed only in 1580, is closely related to S. Caterina, the same type sixteen years later (fig. 14).

Its effect is more weighty and animated. The basement is low, the pilasters are broad; a heavy attic over the first order gives the lower storey predominance. The attic is pierced by an upper window, and the coping of the pediment has a strong lateral projection. Horizontally the façade

is articulated by outer bays, recessed together with their volutes; the pilasters at the ends of the main body have additional half-pilasters forming a gradation to the outer bays, a feature still absent in S. Caterina. The plasticity of the decorative features is greater at the centre, for the outer bays are narrow and left completely empty and the area of the capitals scarcely filled in. The vertical development consists of a Corinthian order surmounted by a composite order. The tablets above and below the niches are violently contrasted; the lower ones are sedate, base-like supports, the upper ones free and decorative. There are further contrasts in the treatment of the two storeys: the doorway carries a tablet with a powerfully projecting frame that pierces the area of the capitals, and the upper storey is quieter, although the contrast is still imperfectly worked out. In other respects the façade of S. Maria ai Monti is one of the best in the baroque style.

The *Gesù* is Vignola's typical baroque building. When he died in 1573 the façade (fig. 15) was not yet begun. His successor Giacomo della Porta designed a new façade (fig. 16) which was completed in 1575. In both their projects the system is the same: receding outer bays, double pilasters, an accented centre bay with columns instead of pilasters, and a doorway with its own pediment. But though the means differ little the general effect is entirely different. Vignola's design seems calm and clear and almost Renaissance-like against della Porta's; its impact depends largely on the old feeling for well-defined articulation and independent components. The first difference in the two designs is the relationship between the storeys. In Vignola's both have equal weight, but in della Porta's the lower storey predominates and the upper is no more than a superstructure. Through this simplification the forcefulness of the façade is much enhanced. Both storeys are articulated with coupled pilasters. As an additional articulation Vignola introduced

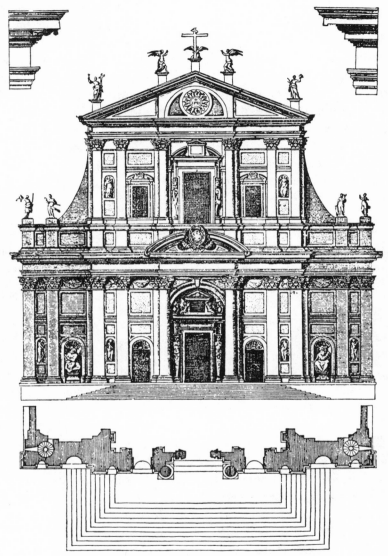

Fig. 15 Il Gesù. Design for façade by Vignola

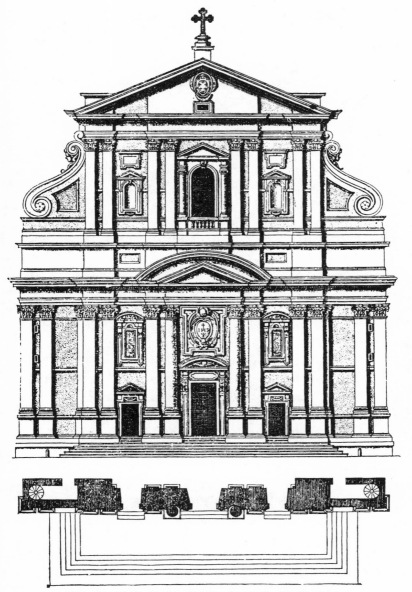

Fig. 16 Il Gesù. Design for façade by Della Porta

string course two-thirds of the way above the base of the lower storey, and three-quarters in the upper. The resulting intervals have simple, rational proportions and are filled by niches or regular moulded frames, each, however, treated as an independent form. Even the pilasters, though coupled, act as independent elements through the niches and frames inserted between them, not as mass.

Della Porta abandoned this method. He placed pilasters as close together as possible and removed all intervening decoration. He left the bays whole and unarticulated, and a narrow strip-moulding half-way up hardly affects their unity. Mass must act as mass, and the form of the bays, defined on the wall with pilasters, seems accidental, with no frames to give them independent importance. Moreover, della Porta had no interest in breaking-up the wall with large niches, as Vignola had done in the outer bays so as to continue the doors. He left them empty, creating a massive and enclosed effect which is relieved only in the centre, and there only to a limited extent; the plastic quality of the columns is more limited, and the portal has none of the free quality of Vignola's triumphal arch. But even with all this reticence, the horizontals and the verticals are effective – for the first time, indeed, on such an impressive scale. Forms that weight down predominate: bases, cornices, attic, pediment and volutes are all considerably more massive. Architectural forms are used to express an almost oppressive solemnity.

Another church attributed to Giacomo della Porta, S. Luigi de' Francesi, falls entirely outside this line of development. Indeed, it is so tentative that one is reluctant to ascribe it to the master of S. Maria ai Monti and the Gesù.[6] The bleak façade reveals none of the principles progressively embodied in della Porta's other churches. The upper storey, in following the precedent of S. Maria dell' Anima, is of the same width as the lower, while the pediment covers only the

three central bays. But how inadequately this huge surface is articulated! Every means has been tried: superimposed pilasters, blind arcades, round and angular niches, recesses, and reliefs, forms which Porta never uses elsewhere, and all are meaninglessly spread over the façade. Of vertical development there is no trace.

Façades by Martino Lunghi the Elder also lack distinction. Lunghi was an inhibited northerner, who looked around anxiously in Rome for models and owed his best ideas to the inspiration of Giacomo della Porta. His S. Atanasio, completed in 1582, is a tedious building. The angle turrets flanking the pediment are of north Italian origin,[7] as are the graduated recessions in the upper storey, a device much used in the later baroque[8]. Lunghi's second building, S. Girolamo de' Schiavoni (1585), is an uninspired repetition of Della Porta's early style. In general it follows the system of S. Caterina; the indecisive ornamentation brought from the north is timidly combined with the new Roman tendency to subordination. The general impression is not unpleasant, but our concern is with the evolution of a style, not with its second-rate exponents.

The master of S. Maria Traspontina is another secondary figure whose timidity is revealed in the proportions of his church. The façade has three equal central bays; the detail, on the other hand, is lively and vigorous, suggesting the hand of a second artist.[9]

Francesco da Volterra built the competent S. Maria di Monserrato but, for all its sumptuous detail, this does not go beyond S. Caterina de' Funari. And what is new in S. Giacomo degli Incurabili belongs to Carlo Maderna, who completed the façade.

With Maderna a progressive force appears again. Maderna began where Giacomo della Porta had left off and then went his own independent way. Through him the idea of the baroque was carried forward with a truly impressive

power; his search moved consistently towards what was significant in mass and movement.

His first independent creation was the façade of *S. Susanna* (pl. 6), and it remained his best, combining a magnificent power with a remarkable control. The façade is graduated in three stages from the centre outwards, in terms of a plasticity that progresses from columns to half-columns, and from half-columns to pilasters. The outer bays are not left empty: the decoration, begins with the two superimposed tablets, progresses to a sumptuous overflowing richness in the centre bay. Niches with their statues, pediments, garlands are all richer and more animated than before. The profusion of the decoration diminishes as the building rises: the upward movement is strongly emphasised and only plays itself out in the regular decoration of the tympanum. But in contrast to Della Porta, Maderna already betrays a certain softening of artistic serenity; the pressure seemed to be lifting, and the dominance of the horizontal was weakening.

The façade of the Chiesa Nuova (S. Maria in Vallicella), by Fausto Rughesi (not Martino Lunghi), is under the influence of S. Susanna. It is considerably weaker; even Maderna did not maintain his own standards, and in St. Peter's his inspiration forsook him (pl. 7). Unable to make a virtue of simplicity, he tried to compensate with richness and variety, and the result is noisy and unpleasant. With St. Peter's the style enters its second phase, and this does not concern us here.

One of the later followers of the first masters was the admirable Soria. He was responsible for a whole series of church façades, including S. Maria della Vittoria, S. Caterina da Siena, S. Gregorio Magno, and S. Carlo de' Catarinari. Their value lies in the severe handling of the masses of travertine rather than in any lively or ingenious composition. Soria is the representative of the Roman

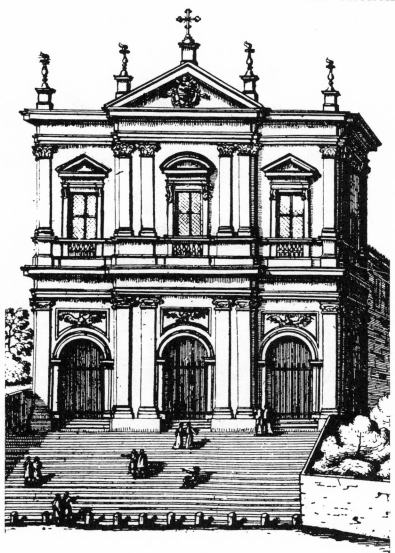

Fig. 17 S. Gregorio Magno. Façade and steps

gravitas. He was also completely independent, and made only moderate use of the devices of a highly-developed style.

His best known work was *S. Gregorio Magno* (fig. 17) on the Monte Celio. This church, lying some way back from the street, was to be provided with a narthex of piers, and a façade with a monumental approach. Soria's solution showed little genius, but great competence. The flight of steps has already been discussed; the steps are regular, as wide as the façade, and the only articulation is the division into three flights. The façade has two storeys of three bays, articulated by double clustered pilasters and pierced by arches in the lower storey and windows in the upper. These

Fig. 18 St. Peter's—Bramante's plan

are fairly small, and do not weaken the general effect of solidity and massiveness. The pediment covers only the centre.[10] Milizia complained that the architect could have made better use of the site: 'Given such an elevated position and so much space in front of the building, it should have been possible to create a painterly vista, so that both the

courtyard and the façade of the church behind it could have been revealed to the spectator at once.'[11] Though his reproach is partly justified, it is directed against the conception, not the executive skill, and an opulent, painterly vista is not in accord with the severe taste of the early baroque.

In the *church interior*, the baroque demands as much height and width as possible, but the impression of this is not achieved by a proportional increase in size. Bramante's St. Peter's is not a baroque building; around the great area of the main dome are four subsidiary domed areas which, although they may not diminish the central crossing, act as

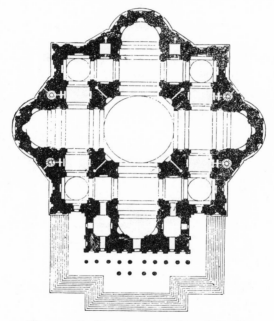

Fig. 19 St. Peter's—Michelangelo's plan

a counterpoise. They assert their independence against the great central area, mitigating the impact of the overwhelming size that Michelangelo, on the other hand, depends on completely for the effect of his design. He decreases the size

of the subsidiary crossings to such an extent that they hardly count, and in this way achieves a central space that totally dominates and controls the rest. In Michelangelo's plan the diameter of the subsidiary areas is only a third of that of the central crossing $(d:D = 1:3)$; in Bramante's they have more than half the diameter of the dome (the ratio of d to D being that of the golden section).[12]

This desire to gain the greatest possible undivided space is naturally combined with another: to articulate the whole interior with a single order. All reference to human proportions is abandoned in order to achieve this specifically baroque aim of overwhelming. If Bramante used giant orders, it was always in conjunction with perfectly formed

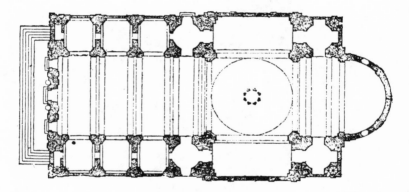

Fig. 20 Il Gesù. Ground plan

elegant smaller columns which served as a gauge. In this way the colossal order becomes less menacing and is brought within our comprehension; our response is a more tranquil one for finding forms closer to ourselves, undisturbed and communicating a sense of poise and assurance.

Michelangelo, however, aims exclusively at the immense (fig. 19). Smaller forms can no longer survive independently beside them. Where they occur, as in the palaces on the

Capitol, they are constricted and inhibited. In this respect one may recall the ground floor columns, pressed against the piers by the weight forced on them. Man, one feels, must bow before this overwhelming force.

The Renaissance interior was designed to be dominated by man; he can comprehend it in terms of his own stature and movement. But in a baroque building man is swallowed up by the colossal space that engulfs him: it is on this principle that the baroque interior is designed.

The longitudinal nave with chapels. The new, simplified ground plan of the Gesù provided the archetype (fig. 20). It has a nave of considerable height and width; aisles are replaced by a simple row of dark chapels,[13] which claim little attention and act as transitions rather than as features arresting in themselves. The 'painterly' design of the large wall-altars completes the effect of blurred contours and leads the spectator's imagination beyond their physical limits. The Renaissance chapel had been lit in every corner. Transepts in the baroque remained as unevolved as the chapels and are seldom any deeper than them;[14] the choir terminated in an apse.

While aisleless churches were built throughout the Renaissance, they were always on a small scale. Large spaces had to be subdivided. The novelty of the Gesù lies in the translation of the aisleless nave into larger terms. If we look for transitional stages, we must go to Michelangelo's alterations to Bramante's St. Peter's. For Vignola, S. Maria degli Angeli was more influential and may have been a direct model. In this church, as is well-known, Michelangelo had the task of transforming a room of the Baths of Diocletian into a Carthusian church. Michelangelo was not a man to respect the old for reasons of piety, and if he retained the longitudinal shape, this was because it conformed to his own ideas. The time had come when the spatial conceptions of the late antique were again understood; the

Renaissance had been more concerned with the central plan of the Augustan Pantheon. To articulate the walls Michelangelo had already used chapels of the kind seen in the Gesù, though walled up again in the eighteenth century.

In spite of S. Maria degli Angeli, it is Vignola who must be credited with the clear formulation of the type. Beside the Gesù, everything that came before looks small and constricted. Eventually his nave was even to influence the extended nave of St. Peter's; though aisles could certainly not be avoided, they were in St. Peter's deprived of all spatial independence, resolved into oval cupola spaces, and made almost invisible from the nave by the broad piers (pl. 11)

The Baroque did not for long sustain the idea of a unified space whose meaning lay only in its dominant relationships. Early in the seventeenth century a taste for the painterly, in the sense of greater variegation, began to make itself felt in elaborate vistas, interesting foreshortenings and other effects only obtainable with free-standing colonnades and spatial subdivisions. With this new breaking up of space the sense of absolute size also disappeared.

A very unusual example of this late phase was the church of S. Maria in Campitelli. In northern Italy, particularly Venice, architectural taste had always been subject to such painterly influences. How different even Palladio's Redentore is from its Roman models, with its division of space, the crossing separated from the nave, and the vista through the further columns into a new area.

The barrel-vault. The baroque nave was covered by a barrel-vault. It is un-baroque to break up a nave into a series of dome-covered areas, a favourite practice in Venice and one used even by an artist as near to the baroque as Pellegrino Tibaldi in S. Fedele in Milan and S. Ignazio in Borgo S. Sepolcro. The barrel-vault served the aims of the baroque by retaining as far as possible the unity of the nave.

According to Alberti, it also had more 'dignitas' than a flat ceiling. Above all, it conveyed an impression of movement, by seeming to be ever in a state of new formation, so much so that given certain proportions it seemed actually to rise upwards. Originally vaults were articulated with wide strips corresponding to the pilasters dividing the bays. Later the structural articulation was increasingly eliminated, leaving the whole surface as a field for decoration.

The use of the barrel-vault always depended on the question of lighting. Until it was pierced with openings it could not become an important feature. These openings took the form of lunettes, with variously shaped windows. This was the only means of obtaining the top light essential to an ecclesiastical atmosphere. In a small church like Alberti's S. Andrea in Mantua – a building that approaches the baroque[15] – the barrel-vault could be left unilluminated with the dome as the only source of light.

The earliest lunettes with semicircular windows were in the vault of the Carmine in Padua, and still belonged to the fifteenth century. In S. Maria degli Angeli, with its cross-vaults, there was no problem. The decisive case was the Gesù, though the present decoration there belongs to a later period (pl. 10). In St. Peter's the vaulted windows in the front part of the nave were added by Maderna.

Treatment of the wall. The wall of the nave was pierced by chapel-entrances taking the form of arches framed by pilasters as high as the wall.

The unity of the wall order was something to which the Renaissance came slowly. Aisle-less churches with flat ceilings, such as Cronaca's S. Franceso al Monte in Florence of 1500, had two complete superimposed pilaster orders; the lower framed the entrance arches, the upper the windows. Later Sansovino dispensed with the upper order in S. Marcello in Rome and S. Francesco della Vigna in Venice, leaving the clerestory unarticulated and reducing it to the

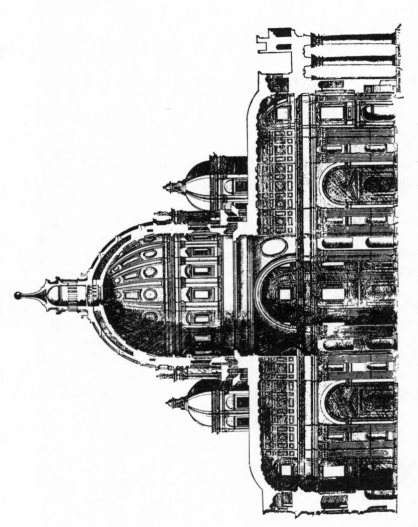

Fig. 21 St. Peter's. Section of transepts. Michelangelo's design

proportions of a kind of attic. With Alberti, in S. Andrea in Mantua, the vaulting is combined with a unified wall system, but in larger buildings two orders were the usual practice for the nave, especially in centralised churches.

Bramante's projects for St. Peter's show that he had originally planned a double order and then changed his mind in favour of a single giant order of pilasters combined with columns of ordinary size; he finally decided on a pure colossal order, banishing the small columns to the ambulatories in the four arms of the Greek cross. Michelangelo removed them even from there, and his system remained the norm for Roman buildings (fig. 21). In northern Italy a certain pettiness in this respect was never overcome, and buildings rarely approached the Roman sense of grandeur. Even in Rome the late baroque brought with it a tendency to use small elements again.

Walls were articulated by means of pilasters because the pilaster is necessarily expressive of dignity and solemnity. In northern Italy the column was never quite abandoned, as the works of Palladio show, but in Rome it only reappeared in the second half of the seventeenth century, to be reintegrated first into the façade, then into the interior.

The simple pilaster could not articulate the huge wall surfaces by itself; in St. Peter's Bramante doubled it and squeezed two superimposed niches between each pair. In the Gesù (fig. 20), where the proportions are smaller, the pilasters are still coupled, but there are no niches (cf. the removal of niches from the façade by della Porta). In smaller churches the single pilaster was retained. The superimposed pilaster was introduced in S. Andrea della Valle, and S. Maria in Campitelli has large groups of free-standing columns, announcing the beginning of the more luxuriant style.

The detailed formation of the pilaster depended on the spirit in which it was used. In the early period of baroque

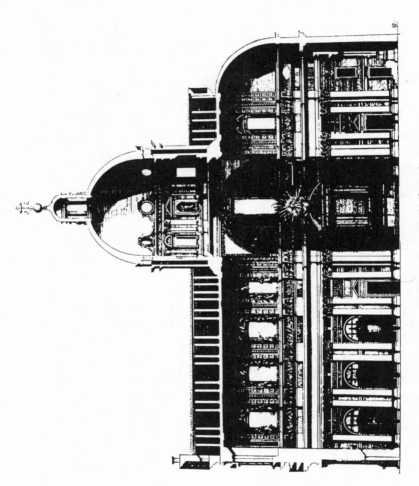

Fig. 22 Il Gesù. Longitudinal section

the pedestal is low and heavy; Michelangelo had the floor
of S. Maria degli Angeli raised to reduce the tall pedestals
of the antique columns. Eventually, when the articulating

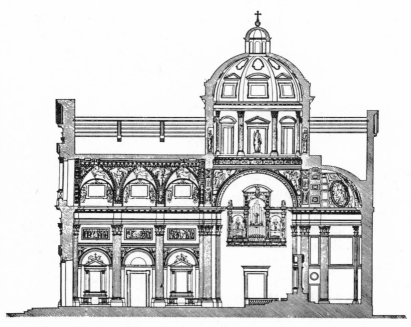

Fig. 23 S. Maria ai Monti. Longitudinal section

members were more freely formed, the base was also raised,
since its function was to lift the columns off the ground (a
development that corresponded to that of the basement on
the façade).

The treatment of the attic was even more significant. The
baroque demanded that it should be heavy and ponderous.
In S. Maria degli Angeli Michelangelo buried the slim
springing of the cross vault in an oppressively rich attic.
The attic of the Gesù is simpler, but even heavier (fig. 22).
Later the pressure lifted again and the attic gradually
disappeared altogether.

119

The arch of the chapel entrance filled up the entire bay in the Renaissance and reached up to the entablature, to which it was connected by a keystone. In the baroque it was often so low that a considerable space was left between the extrados and the architrave. This is the case in the Gesù, where the intervening space is partly used for a gallery, and also in S. Maria ai Monti (fig. 23) and the Chiesa Nuova. The key-stone had gone, and returned only with the renewed tendency to vertical accentuation, accompanied by sitting and recumbent figures which animated the spandrels and gave an even stronger feeling of upward direction. In St. Peter's these figures increased in weight as they approached to the entrance, so that the last seemed on the point of being hurled to the ground by their own weight.

Last of all the entire composition of the wall becomes more agitated: we can see what trouble Borromini took to bring a riot of movement into the walls of the old Lateran basilica. But in this way the church interior sacrificed a great part of its effectiveness, its contrast with the façade. Hitherto a large serene interior provided a foil for the agitated exterior, but with Borromini both shout as loudly as each other.

The quickening of the pulse is felt distinctly in the changing proportions of arches and bays. These intervals became even smaller, and the arches taller, and they follow each other in quicker succession. This can be seen if one compares the Gesù with S. Andrea della Valle. In St. Peter's it is also noticeable how much closer together Maderna placed the piers than his predecessors had done.

A new baroque device was to follow the three equal bays of the nave with a narrower bay before the crossing, and this was repeated between the crossing and the apse. It usually contained only a small door, not an arch. Though the ostensible intention was to strengthen the support for the dome itself, it was also a most effective visual preparation for the impact of the area of the dome.[16]

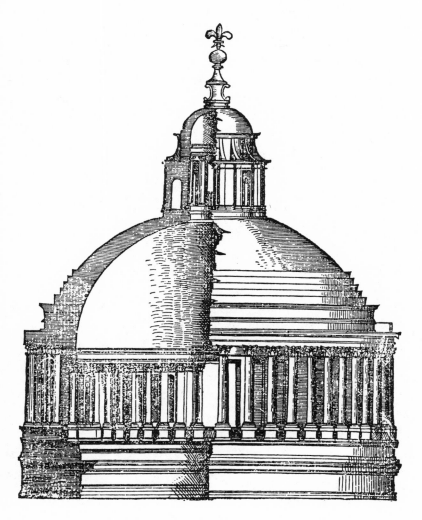

Fig. 24 Bramante's design for the dome of St. Peter's

The usual features of the baroque dome are, firstly, a round – not a polygonal – drum; secondly, articulation by pilasters or columns, both inside and out; thirdly, an attic; fourthly, a steep, ribbed curve; and, fifthly, a lantern with some crowning accent. St. Peter's naturally became the prototype for all future domes. Although Michelangelo had carried it only as far as the drum, he had left a large wooden model after which Giacomo della Porta completed it in 1588 (pl. 8).

Bramante's project had been a segmental dome with graduated layers, like that of the Pantheon. It was to have floated over a ring of free-standing columns which would have formed an ambulatory (fig. 24). The general effect was broad and static, in contrast to Michelangelo's, which, straining upwards with strength and sinew in every line, never becomes gothic and insubstantial.

The difference between the two is described by Geymüller: 'The calm and unity of Bramante's dome manifest themselves clearly and exquisitely in the broad colonnade and the rings supporting its springing. Here the drum is the most important feature and floats over the tomb of the chief apostle like a noble crown, surmounted only by the necessary ceiling, which, in the form of an elegant saucer-dome, rests lightly on the colonnade. Michelangelo divides the colonnade into single buttresses with paired columns, thereby increasing the verticality, but also the load. His dome, furthermore, is much more massive.'[17]

After Michelangelo the history of the dome is essentially a matter of periodic alterations of proportion; the system remained the same. As all forms tended to become heavier, the dome also became more depressed in shape; later it recovered again and became slimmer from one decade to the next, inside as well as outside. What Burckhardt calls the impression of serene floating which the cupola of St. Peter's makes on us, turns more and more into impetuous upward

movement. We are reminded of a similar phenomenon in painting, where saints no longer float in the air, but rise upwards in feverish haste. The dome of the Gesù is only three times as high as it is wide (measured in the interior from the ground), while that of S. Andrea della Valle is exactly four times as high. Giacomo della Porta increased the height of the inner shell of the dome of St. Peter's by one-third of that projected by Michelangelo, though he did not thereby disturb the serene effect of the vast space.

The main purpose of the dome, however, was to direct into the church the shafts of light essential to an atmosphere of sanctity. In contrast to this celestial light, the nave was kept relatively dark, and the chapel recesses fade into impenetrable gloom. Space seems limitless, comparable with the dark backgrounds of paintings. These are the effects of light first discovered by painters, now carried to the loftiest and most stupendous effects. It is the baroque that first uses light as an essential element in the creation of mood. That the interior was generally darker than in the Renaissance is consistent with the heavy forms; when these later breathed more freely, the church interior also became lighter.

II. THE PALACE

The secular architecture of the baroque style stands in remarkable contrast to the ecclesiastical. After the vigour and magnificence of the church façades, the severe, unassuming palaces are so unexpected, that one is inclined to think that in palace architecture the baroque period saw no stylistic development at all. At first sight it seems impossible that the same Maderna who built S. Susanna (pl. 6) could also have designed the Palazzo Mattei (Mattei di Giove), near S. Caterina de' Funari, a building completely dominated by horizontals, large, unadorned, joyless, almost gloomy.

The truth is that the baroque spirit is present here also, but that the palace façade followed different rules from that of the church. The palace must be seen in terms of an external architecture, counter-balancing an interior of completely different conception: the one cold, forbidding and formal, the other sumptuous and intoxicating. This was the period of formality in the Spanish manner: stiff and strained behaviour and a formal tone in place of natural vivacity, a uniform conventional manner[1] instead of individuality and diversity. This new spirit had a decisive effect on the palaces of the aristocracy. Antonio da Sangello provided a model for it in the house he built for himself, the Palazzo Sacchetti (pl. 14), when he became a gentleman of fashion in Rome. The correct tone was achieved by eliminating all original or lively features and reserving freer treatment entirely for the interior. The only exception to this rule for palaces were public buildings and the palaces of the Popes, which did not

need to conform to social laws; these could show more freedom and more sumptuousness to the outside world.

The typical Florentine palace was tall, dry and completely untouched by the Roman feeling for solemnity, calm and grandeur or by its broad and sumptuous manner. The gay and lively palaces of Genoa, which become the instruments of a happy, festal spirit in the hands of Galeazzo Alessi, are in a different way quite un-Roman in character and hardly baroque at all.

At the time of the religious revival the Roman palace was a large, solemn and elegant building. Its walls were of brick and covered with a smooth stucco. Articulating members such as quoins, cornices and windows were of hewn stone. This system, seen already on the Palazzo Venezia, had been discarded by Bramante but was brought back by Antonio da Sangallo; the greatest example was the Palazzo Farnese (pl. 13).

Completely unworked rusticated stones were no longer tolerated, even on the ground floor; they were banished to the less formal country villa.[2] Nor was the pure ashlar of the Cancelleria in tune with the baroque sense for massiveness. When possible, the wall was left whole and unarticulated. In Bramante's system every window had been incorporated into a harmonious composition of pilasters and cornices, and each member, necessary and unchangeable, seemed made for its part in the whole. Where vertical members were rendered superfluous by the half-columns flanking the windows, they were replaced by string-courses on the level of the base of the pediment to prevent the windows becoming disconnected from the whole. This can be seen in Raphael's Palazzo dell' Aquila (fig. 25) and his Palazzo Pandolfini, in Baccio d'Agnolo's Palazzo Bartolini and Antonio Dosio's Palazzo Lardarel.[3]

It never occurred to Sangallo to use a string-course to connect the window-gables of the Palazzo Farnese, nor did

he use pilasters or half-columns to articulate the walls; if, to
a certain extent, they were here replaced by the columns
flanking the windows, these too presently disappeared, and
nothing was put in their place. Mezzanine windows were
sometimes audaciously left floating in the air, as in the Pal-
azzo Sacchetti (pl. 14),[4] and eventually all structural sup-
port was removed from whole storeys, as in Ammannati's
Palazzo Ruspoli. With the later baroque the pilaster re-
turned; Bernini's Palazzo Odescalchi became the model for
all subsequent buildings.

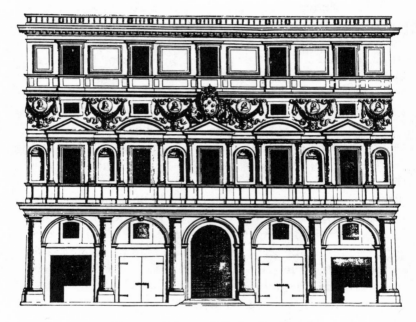

Fig. 25 Palazzo dell' Aquila. Façade

The ratio of opening to wall was governed by the same
feeling for compactness and massiveness. The broad windows
of the Renaissance were abandoned; in their place came
windows of an increasingly elegant, almost unnaturally
slender form, subordinated to the mass of the wall. More-

over the storeys became so much higher that a large space was created above the windows.[5] Where the ground floor was completely closed and unarticulated, as in the Sapienza (possibly designed on the model of the Villa Giulia), the effect was very forceful. There was no question at all of filling in the surfaces with decoration.

From the second quarter of the seventeenth century this style also was transformed.

Horizontal Composition. The palace façade was usually conspicuously wide in proportion to its height, for a stable and comfortable breadth appealed to the taste of the time. Even extreme cases, like the Palazzo Ruspoli with its nineteen bays, have neither protruding wings (as the Cancelleria had) nor a central projection. The whole building formed one single mass. The Palazzo Barberini belongs already to a different stylistic phase.

An interesting form of horizontal development was the rhythmic disposition of windows one finds on the rear façade of the Sapienza (fig. 26), perhaps originating with Michelangelo, and much used by Giacomo della Porta, in, for example, the Palazzo Chigi in the Piazza Colonna. The windows crowd into the centre of the façade with a lively movement, while the isolated outermost ones mark a static point of departure for the sequence.

Vertical composition was no longer a matter of a succession of independent storeys becoming lighter as one looks upward, or of a composition of equal parts. In the baroque palace one storey is decisively predominant; the others must yield to it and depend on it for meaning, and aesthetic value. The main storey was brought to such a pitch of ornamental richness that the upper one by comparison lost its independence. One means to this predominance was the formation of the windows:[6] These are severe and constricted on the ground floor, quite simple on the top floor, but on the middle floor they are broad and stately, with powerfully

Fig. 26 Sapienza. Façade

projecting pediments, consoles and sills. The main effect, however, was obtained by making this storey of imposing height. It corresponded to the great *saloni* inside, but as a single row of windows which reached hardly half-way up the walls was not enough to light such huge spaces, a second row of smaller openings had to be made, and these appear on the outside of the palace in the form of a mezzanine. In a few cases these windows correspond to an actual half-storey inside.[7]

The *mezzanine* was now no longer concealed or used as a merely decorative feature as it had been in the Renaissance. It assumed an architectural significance of its own, and often helped to give a spirited movement to the vertical rhythm of the façade. Its windows were placed either slightly more or slightly less than half-way between the large windows and the cornice, never exactly in the centre. The most delicate perception of ratio was necessary to make a harmonious composition out of such variously sized windows, but there are a number of fine examples in which the upper row of windows forms, as it were, a mean between the main windows and those of the mezzanine, and so provides a satisfying conclusion.

The Florentines never came to terms with the mezzanine; even in Rome it was abandoned together with the principle of the unified façade on the return of equally balanced storeys. This is shown by buildings like the Palazzo Altieri and occasional earlier examples such as the Palazzo Sciarra.

The unified façade was already appearing in Bramante's late Roman period. The Palazzo Giraud differs from the Cancelleria in that its main storey is more prominent. At the same time the vertical joins disappeared from the ground floor, so that it assumed the character of a simple basement. The ideal demonstrated here is realised more clearly still in Bramante's last phase, represented by the House of Raphael (fig. 27). This has a rusticated ground

Fig. 27 Bramante: The 'House of Raphael'

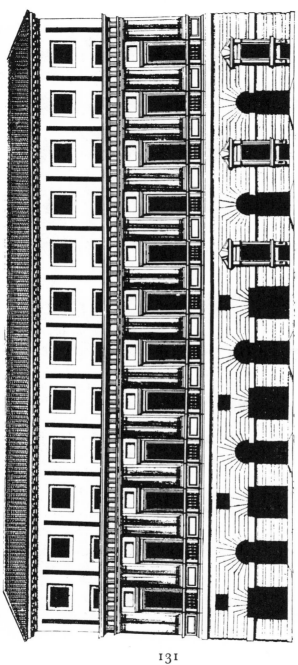

Fig. 28 Raphael: Palazzo Vidoni – Caffarelli

floor, definitely basement-like and surmounted by an order of coupled half-columns. The next development was made by Raphael, who added a third storey as an attic to the Palazzo Vidoni-Caffarelli (fig. 28).[8] Peruzzi's Palazzo Costa is similar, but here the half-columns are reduced to superimposed pilasters.[9]

The kind of unity achieved by this method did not as yet appeal to that formal conception of the baroque which demanded that a façade should be one single, large, regular mass, without division into separate parts. This accounts for the avoidance of strongly pronounced cornices, of contrasts in the treatment of wall surfaces and of orders of columns and pilasters. What matters is the proportion of the masses, not the disposition of particular forms.

The first important façade conceived in this spirit, without mezzanine, would have been Antonio da Sangallo's Palazzo Farnese; but it was altered in the final stages by Michelangelo – certainly not to its advantage – who raised the cornice more than six feet, spoiling the proportion of the windows, which now became too small (pl. 13). Antonio's intention had been to place the cornice quite close above the gables of the upper windows, in order to emphasise the effect of the main storey with its large windows and the extensive space above them. As it is, the weaker repetition of this motif on the second floor destroys the effect. The idea was not forgotten, however, and re-appears fifty years later in the Lateran palace of Domenico Fontana, though not in the happiest form – a truly baroque conception then as before.

The façade with a mezzanine above the main storey was already known in the Renaissance; the most important example was Raphael's Palazzo dell'Aquila (fig. 25).[10] Only the arches on the ground floor were completely unbaroque. The next stage was Sansovino's Palazzo Niccolini. Here it is clear that the baroque involved a new way of

manipulating existing forms – especially in the proportions of windows to storeys and of the storeys to each other – rather than an entirely new system. Shops are no longer let in to ground floors. Peruzzi's Palazzo Angelo Massimi next door to the Palazzo Massimi alle Colonne, already shows an interest in effects of mass. Sangallo's own house (Palazzo Sacchetti) is valuable as an expression of the artist's own personal convictions (pl. 14). A disturbing element remained in the large ground floor windows of this building, for the well-developed 'finestra terrena' which was common in Florence did not go well with the basement-like ground floor. Vignola's Palazzo Mattei-Paganica is also typical.

Of great importance was Vignola's Palazzo Farnese in Piacenza, begun in 1550, under the influence of Sangallo. It has five storeys, composed in such a way that, for the spectator, only the main storey seems to exist. The general effect of mass is tremendous, unbroken by any kind of vertical division. The mezzanine windows, which are square in the Bolognese manner, still rest on their own subsidiary cornice. But a certain timidity in the proportions cannot be denied, and the palace lacks the full grandeur of Roman buildings.

As in ecclesiastical, so in secular architecture, it was Vignola's pupil Giacomo della Porta who took the decisive step that gave the baroque palace its characteristic massiveness and animation. The Palazzos Paluzzi, Boadile and a nameless palace in the Via del Gesù, now destroyed, were still modest and sedate, but his later buildings, the Palazzos Chigi, d'Este and the unfinished Palazzo Serlupi, are fuller and achieve the characteristic baroque tension.[11]

Articulating forms. The basement or pedestal of the Cancelleria occupies one-quarter of the total height of the ground floor (pl. 12). In the Palazzo Farnese the basement takes the form of a projecting bench and is considerably lower (pl. 13), while in later buildings it was hardly

indicated at all, though represented by shallow mouldings, it was in effect replaced by the ground floor as a whole.

String-course mouldings were also reduced to simple strips, so as not to form noticeable interruptions. In the transitional period fully modelled bands decorated with a meander pattern, over an ornamented frieze, were common. In earlier buildings, still articulated with pilasters, a full entablature was normal, and in Florentine palaces this was retained until much later, to correspond with pilasters at the corners.

In the Roman palace the corners were occasionally not accented at all, but more often they were formed by quoins whose alternating sizes made the contours of the building seem agitated and restless. Sangallo intended to have angle pilasters on the Palazzo Farnese, but they were replaced by rusticated pilaster strips. Such pilasters were used for the last time in Rome on the Villa Giulia, but there they derive from Florentine architects. As a motif they contradicted the massiveness of this baroque.

As the top storey was so small, the cornice could only project slightly, and in respect of its strong projection Michelangelo's much-admired cornice on the Palazzo Farnese had no imitators. On the whole, the cornice remained uncertain in formation. In Florence the projecting pitched roof continued to be the rule.

The frieze which ran under the cornice – in Raphael's Palazzo Pandolfini a fine, broad strip without ornament – was usually omitted from Roman baroque buildings as being too static. When it did occur it was very narrow and covered with ornament, as on the Palazzo Farnese and on the Lateran palace, where it is even narrower.

The window in the baroque style no longer had any claim to independence. It lost the aedicula which had once given it the character of a house inside a house[12] but now made it too conspicuous for the baroque taste. The pilaster

or half-column was replaced by a simple strip, often gradu-
ated by several backward stages to the wall surface, and the
pediment was supported by consoles running into these.
This was the basic baroque form. It can almost certainly be
traced to Michelangelo, for its first appearance is in the
Palazzo Riccardi in Florence,[13] its second in the new sacristy
of S. Lorenzo, then on the second storey of the courtyard of
the Palazzo Farnese (pl. 17). Peruzzi also used it in his
early work, in the Palazzo Linotte and, without strips, on
the Palazzo Costa. The windows of Bramante's House of
Raphael have pediments without consoles (fig. 27). Later
windows were enriched by coupling the consoles, one pro-
jecting from the wall, the other facing sideways, as in the
Palazzo d'Este by Giacomo della Porta. Another means to
enrichment was the interruption of the pediment's base-line
and the support of the ends by triglyph blocks above the
lintels.

Pediments were sparingly used and usually kept for the
main storey. Sometimes they were substituted by a simple
cornice, with or without consoles, especially on ground
floor windows if the ones above carried pediments. In this
case the upper windows were framed with only the severest
of mouldings.

The shape of the window-sill had also changed. In earlier
times each window had had its own sill. This would now
have been a gesture of independence and so was reserved
for the most important places. The other windows were
placed directly on the string-course,[14] and this was invari-
ably so in the case of the top storey.

For all the reticence of baroque palace architecture, the
tendency to emphasise the upper parts of structures was still
present. Thus, although a horizontal roof-line in itself need
not be assertive, it could be turned into a strong accent if
permitted to project sufficiently and cast a powerful shadow.
The formation of window-pediments is even more expressive

of this vertical thrust. In contrast to the perfectly regular form of the Cancelleria windows (pl. 22) the sculptural effect is concentrated at the top. The Palazzo Giraud shows symptoms of change: the pilasters framing the windows are left undecorated and all ornament is crowded into the spandrels of the arches.

The doorway. The external placing of the doorway was conditioned by the need for a large opening to allow for the passage of carriages.[15] This practical necessity fitted well with the stylistic aims of the baroque, expecially in its later development. The main entrance became the show-piece of the façade; in its most complete form it reached up to the main storey, carried a balcony, and was continued by a central window enriched with coats-of-arms and other ornaments.

Early ornamented doorways, framed by columns and half-pilasters, are seen in Sangallo's Palazzo Palma and on the Cancelleria (pl. 12). The doorway of the Palazzo Farnese is rusticated and very sedate; the window and coat-of-arms above it, by Michelangelo, make it the first ensemble of its kind (pl. 23). The more pompous elements, like free-standing columns, are from a later period, not from the more severe phase of baroque. On the other hand, features such as rising ground are always exploited for an imposing effect.[16]

Nowhere, perhaps, had the spirit of the Renaissance emerged as clearly as in the light airy forms of the arcaded courtyard. In Rome the finest such courtyard is in the Cancelleria (pl. 16), but it had no successors, and the rare later cases of arcaded courts were always the work of a north Italian master. Roman *gravitas* needed the court with piers – known, significantly, as 'alla romana'. For the baroque, regular courtyards existed only on a large scale; in the smaller private palaces they had lost their functional importance.

Some of these large courtyards are extremely impressive, both for their size and for their solemnity. The first important model was the Palazzo Farnese (pl. 17), with its *cortile* of piers covering two storeys, topped by a third storey articulated by pilasters. The two lower storeys are by Sangallo, but when Michelangelo took over the building the arches of the first storey were not yet vaulted. For these he chose the depressed elliptical form rather than the semicircle, and he walled in the arches of two of the walls.[17] It had been Sangallo's intention to close the top storey, but here Michelangelo went his own way. He raised its height to correspond with his alterations to the façade, articulated it with the superimposed pilasters and gave it restless windows that are reminiscent of the forms of the Laurenziana, as well as a lively composite cornice. All this was intended as a contrast to the heavy, solemn lower storeys, but it is the antithesis of the light, flexible articulation of the Cancelleria.

The difference between the two is not entirely due to the piers. The Palazzo Venezia in Rome has an early Renaissance courtyard, with piers and half-columns, lighthearted in appearance: there are two airy galleries with buoyant, slender, proportions, the columns rest on tall bases, and there is no suggestion of heaviness in either entablature or cornice. In the Palazzo Farnese the same elements are used in a quite different spirit to achieve a solemn, ponderous effect.

Vignola's Palazzo Farnese in Piacenza – unfinished, and now partly altered – was intended to have two tiers of arcades, the arches separated by broad masses of masonry; the rounded angles were each to contain two superimposed niches, and one side was to have had a giant exedra. What is visible now is only the core, but the original intention of a contrast with the façade is clear. The five storeys of the exterior are merged here into two overwhelmingly large ones.

The idea recurred in the Palace at Caprarola (pl. 18), which was completed by Vignola. There the exterior is a pentagon, while the courtyard is circular; the exterior has four rows of windows, but the courtyard has only two loggias corresponding to the two main lower storeys. The rest is set back and invisible from the courtyard. Peruzzi's plan for Caprarola had had a pentagonal court; Vignola's did not provide for piers, but instead for arches piercing the walls at moderate intervals. The ground floor is rusticated and basement-like, while the first storey has paired half-columns between the arches. The whole is solemn and magnificent.

The later *cortili alla romana* – the most important are della Porta's Sapienza (pl. 20), that of the Collegio Romano by Ammannati and Mascherino's Quirinal – already have an atmosphere of cool grandeur. Half-columns have become pilasters, and the central plan has given way to a longitudinal one.

The private palace now lost its formal courtyard, which could no longer be effective as a large, enclosed space. It was not an independent entity with rights of its own, but something to direct the glance elsewhere; since no one now stayed in it for long at a time, its function became that of drawing the eye into a long perspective, not of implying bounds.

The transition from the central, enclosed *cortile* to the longitudinal took several forms. Side walls were neglected and attention given only to the rear wall and sometimes to the front as well.

The customary fountain was moved from the centre to a niche in the wall. Finally, a vista was created beyond the courtyard to attract the eye into the far distance.

The two successive courtyards of Peruzzi's Palazzo Massimi alle Colonne make for a painterly effect (fig. 29), and in the Palazzo Sacchetti there is a view from the courtyard to a

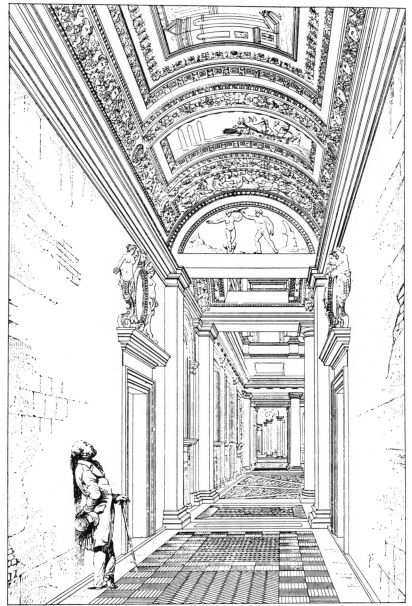

Fig. 29 Palazzo Massimi alle Colonne—view into Courtyard

garden and an open loggia. Michelangelo's project for the Palazzo Farnese provided for a grand perspective view into the garden, with a fountain whose centre-piece was to have been the Farnese bull. In the background a bridge was to have led across the Tiber to the Farnese estates on the other side.[18] Even Sangallo's first project had provided for a vista to a niche in the further parts of the garden.

When a distant view was impossible, an attempt was made to suggest that the magnificence of the buildings was a prelude to some even more attractive novelty. One strange instance of such an attempt to extend space into infinity is the colonnade on the left side of the cortile in the Palazzo Spada, where Borromini has managed to suggest an unending series of columns. If the patron's means were limited, painted perspectives of gardens had to serve, and these are common in northern Italy.

As the baroque style developed, it became fashionable to contrast a sedate façade with an opulent, lively and unrestrained *cortile*. This can be seen at its best in Maderna's Palazzo Mattei (fig. 30). A row of three stately arches in the background, crowned with a balustrade and statues, was to serve as an introduction to a garden. The side walls of the *cortile* are decorated with vertical strips and numerous reliefs, in contrast to the completely plain façade, which is dominated entirely by horizontals. The rear façade is no less magnificent, opening through a two-storeyed loggia – into the courtyard.

The staircase. The pride of the aristocrat's palace was a broad, convenient and well-lit staircase. In the Preface to the *Lives* Vasari says: 'Vogliono le scale in ogni sua parte avere del magnifico, attesochè molti veggiono le scale e non il rimanente della casa' ['Let the stairs be grand in every way, for many see the stairs and nothing more of the house.'] But the Romans never cared for the extravagant staircases favoured by the Genoese, with their ramifications and

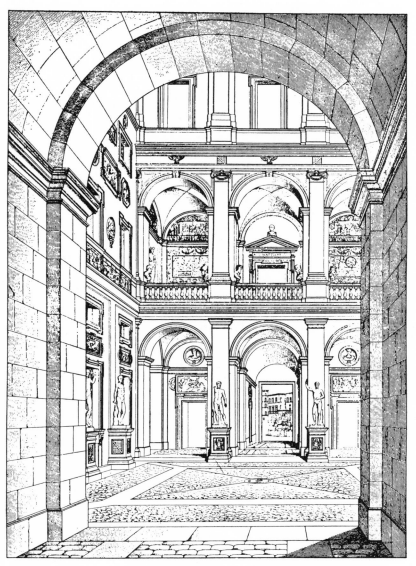

Fig. 30 Palazzo Mattei. View into Courtyard

picturesque views onto courtyards both above and below. The vestibule of the Roman staircase was a simple vaulted corridor leading to the loggia in the cortile. The staircase itself consisted of a single flight between two walls; the open landing half-way up is a later development. Usually there was only one turn, though this increased to two or three in later, more ornate constructions, and these usually had their own lighting. The most impressive form of staircase devised in Rome was a dignified ascent in a magnificent and broad vaulted corridor entirely devoid of decoration. Even in a

Fig. 31 Palazzo Farnese. Section of step.

building like the Farnesina with its generous forms, the staircase is still steep and the corridors narrow. The first building with a staircase agreeable to the modern eye is the Palazzo Farnese, where Sangallo made the steps broad, low and slightly tilted (fig. 31) and gave them the 'dolcezza' prescribed but never achieved by Vasari. The contrast between this staircase and that of the Uffizi in Florence is that between the Roman dignity and grandeur and the drier, harder sensibility of the Florentines. The heavier and more relaxed forms adopted later in Rome were a consequence of the baroque style, though perhaps *dolcezza* was carried to a point where comfort was lost.

The rooms. The *salone* of a baroque palace has proportions like those of a baroque church. If possible, it was very high and very wide, not a space in which man set the scale but one which overwhelmed him. Ceilings were usually flat, made of wood, and ornamented with rich, sculptured mouldings in a restless design. Colour was used sparingly and limited to red, blue and a little gold. Peruzzi's Palazzo Massimi alle Colonne already shows some signs of decorative overcrowding, and those by Antonio da Sangallo in the

Palazzo Farnese and the Sala Regia of the Vatican are heavy and disturbing, the latter being of stucco. The last stage of this development is represented by Maderna's Sala Regia in the Quirinal (pl. 26). As well as flat ceilings there were panelled, vaulted ones, and these were decorated with paintings, at first only in the central roundel, later over the whole surface. This shape was the commonest one in the later period, but in the early phase it was only used in long rooms.

Sometimes the walls were decorated with scenographic views intended to make the room seem larger.[19] Fine examples of such decoration occur with Peruzzi on the first floor of the Farnesina,[20] then with Vignola at Caprarola. The most common type of wall-decoration of the early baroque period, however, is represented by Carlo Maderna's Sala Regia in the Quirinal. Here the lower part of the wall is hung with large tapestries, above which is an empty frieze bounded by a prominent moulding. This disposes of little more than half the height of the wall, and the upper half is filled with an unbroken series of frescoes,[21] a type of articulation that gives the heaviest possible effect (pl. 26).[22] Sometimes plain panelling was used in place of tapestries. But the important factor is the absence of the dado, and pilasters that had marked the pleasing proportions of the surfaces in a Renaissance room.

One interesting innovation was that the most elaborate room was now the long, narrow *galleria*, not a large, central square chamber. Here again is a development from a centralised to a longitudinal conception. Galleries are found in the Palazzo Farnese (by Vignola) and, narrower, in the Palazzo Doria and Palazzo Colonna. Formally the gallery derived, of course, from the loggia; Scamozzi's suggestion that it was of French origin was simply bad etymology.

III. THE VILLA AND THE GARDEN

From the early Renaissance onwards there existed two types of villa in Italy; one was the country villa, broadly laid out, designed and furnished for long stays with a large establishment; the other was the smaller *villa suburbana*, situated not far outside the gates of the town, to be used for short pleasure outings.[1] The main purpose of this second type of villa was to allow a pleasant and harmonious existence untrammelled by the formalities of the town. Hence the lightness and light-heartedness of these buildings, with their open loggias, well-articulated and often asymmetrical ground-plan, and complex of light, pleasant rooms, in Burckhardt's words, 'Transparent and full of light and air.'[2] The most perfect example of the Renaissance town villa is the Farnesina (pl. 29).

Even in these pleasure buildings the baroque style did not quite lose its solemnity. Massiveness took hold of the villa too, and in characteristic fashion the front façade was contrasted with the rear: the one is severe, forbidding, restrained, the other – when not overlooked – sumptuous, exuberant and abandoned.

The town-villa. Let us look first at the *villa suburbana*. Massiveness and restraint were decisive in the rebuilding of the Villa Madama. Raphael's joyful design was transformed by Giulio Romano into an almost sinister grandeur. The tone is set by the solid walls. An earlier work by Giulio Romano, the Villa Lante on the Gianicolo, also lacks light-heartedness; the arrangement of the windows betrays a

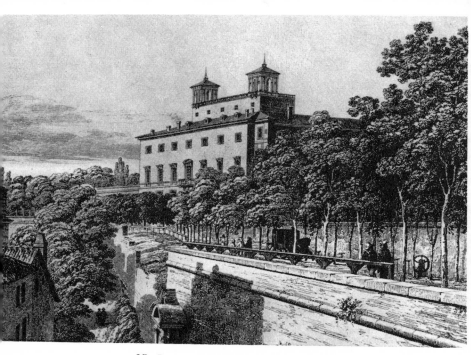

27. Rome: Villa Medici, front façade

28. Rome: Villa Medici, rear façade

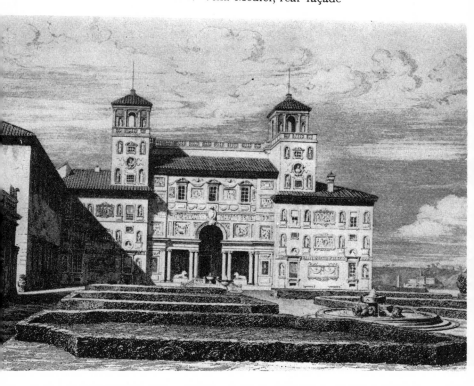

29. Rome: Villa Farnesina, rear façade

30. Frascati: Villa Aldobrandini

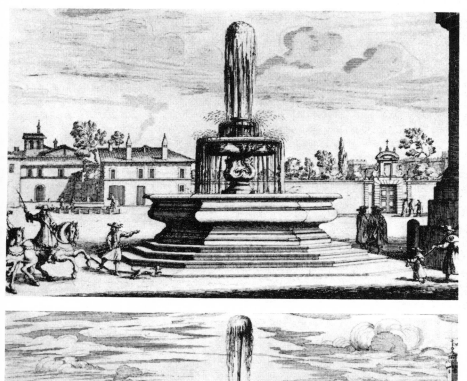

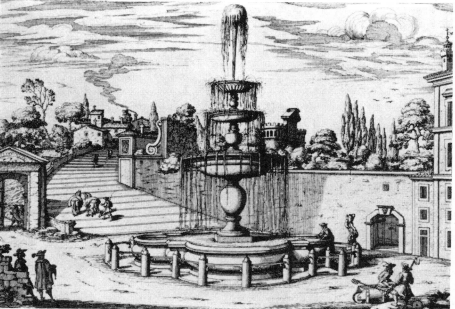

31. Rome: Fountain, formerly in the Piazza del Popolo

32. Rome: Vatican gardens, fountain

33. Tivoli: Villa d'Este, rear façade and gardens

baroque unease. The Villa Giulia is quite abnormal in design and hardly relevant to our argument. It is noticeable that several hands had a part in it, and the whole lacks character.

The first important town villa was the *Villa Medici* by Nanni Lippi. Here the closed façade of the town palazzo was adapted to the villa. The main storey is surmounted by a mezzanine, there are no pilasters, and the windows are unornamented. The front and rear façades are strongly contrasted: the garden façade bubbles over with ornament, protruding wings and turrets, and an open loggia with a central arch; the walls are set with niches, reliefs, garlands and medallions, which in some cases even overlap each other (pls. 27 and 28).

The *Villa Borghese* by Vasanzio is typically baroque in conception. As the building lies far inside a park there is no actual street façade, but the clear contrast between front and rear has been retained. Thus the decorated wall is permitted only under cover of the protruding wings. These however are not independent structures as in the Farnesina; they are not detached from the main mass of the building. Framing strips replace pilasters, and the loggia carries a high attic. The walls lack articulation; the whole speaks of a taste for weight and mass. A comparison between this building and the Farnesina, indeed, shows us most clearly the transition which art had undergone. The one is a completely articulated body, the other has a tightness suggesting that no flexible articulation can be developed.

A special feature of these villas, and one which influenced their design, was the large number of rooms required to accommodate the enlarged establishments, themselves a consequence of the pomp now deemed essential to enjoyment. The Villa Negroni, built by Domenico Fontana for Sixtus V as a cardinal, has pilasters and is unbaroque in feeling, a palace rather than a villa. The Villa Mattei, by

the Sicilian Giacomo del Duca, is also outside the Roman line of development, and Algardi's Villa Doria belongs in every way to the second baroque period.

The design of the interior is similar to that of the palace; the rooms are uncomfortably large. The main *salone* occupies two storeys,[3] and the atmosphere is one of ceremony.

When possible the town villa was slightly screened. The entrance drive was curved so that the house was not visible immediately on entering. The Orti Farnesiani, the Villa Borghese, the Villa Doria, and others, are planned in this way. Alberti, on the other hand, had stipulated that the villa should be situated on a gentle slope and visible immediately on leaving the town: 'tota se facie videndam obtulerit laetam'.[4] In the baroque period, however, only the country villa was sited in this way.

The country-villa. At the end of the Renaissance there was no single type of country villa; there was great variety both in size and design. The Villa Lante near Viterbo is small and *casino*-like; Caprarola is a mighty pentagon like a fortress; and the Villa d'Este in Tivoli is large, severe and closed, in the style of the Roman town palazzo. The Villa Lante, ascribed by tradition to Vignola, is still entirely a Renaissance building, consisting of two small square buildings of equal size. Coupled pilasters frame blind arcades, and the wall surface is lightly rusticated. Caprarola was built by Vignola for Alessandro Farnese, the pope's nephew.[5] It is designed with a view to a very large establishment, with a *piano nobile*, *piano dei cavalieri* and *piano de' staffieri*. The circular cortile is possibly the most magnificent in secular architecture. The Villa d'Este is dry and palatial.[6] The masonry is plain, the windows undecorated; it is a stretched-out building and, unlike the *villa suburbana*, has slightly protruding wings and rusticated pilaster strips. The dominant motif is the vestibule, which closes off the extensive system of staircases and terraces leading up

from the garden, and this central part of the villa is all that can be seen from the entrance drive.

This type of lay-out became more or less the rule for villas built in the vicinity of Rome, but not a single one of these buildings is of any real architectural significance. The Villa Aldobrandini in Frascati by Giacomo della Porta and Domenichino, is uncomfortably shapeless (pl. 30). Its capriciousness, evidently intended to capture a certain rural mood,[7] could hardly agree less with its sombre forms. But the rear façade with its open loggia is freer and lighter: the contrast between front and back, indeed is that of the town villa. The Villa Mondragone by Martino Lunghi, Flavio Ponzio and Giacomo Fontana, in Frascati, is a huge stone pile of no artistic merit whatever, the central part narrow enough to be framed by the avenue of cypresses which form the approach. The Villa Borghese, also in Frascati, is another.

It is only fair to remember that the villa was designed to merge inconspicuously with its surroundings, and not to establish itself as an independent architectural entity; its success, in fact, depended directly on the degree to which this was achieved. It is almost as if a rapprochement between nature and the principles of architecture had been intended.

First of all, the *entrance approach* was given considerable prominence. When possible the villa was sited on an incline high enough to allow the ascent to be laid out in the form of a grand system of staircases[8]; the prototype is Bramante's system of symmetrical diverging ramps in the Vatican (pl. 32). In the Villa d'Este, from a circular area at ground level, there is an ascent in four stages, the whole still in small units (pl. 33). The Orti Farnesiani on the slopes of the Palatine have a most painterly effect with their four levels, each richer and more varied than the last; the highest even has two aviaries placed at an angle (fig. 32). In the Villa Aldobrandini there are broad, projecting ramps studded with small

fountains and lemon trees, but there are no steps at all. The Villa Mondragone has a long, gentle slope lined with cypresses, and in this tectonic elements play no part.

The front terrace. In front of the villa was a terrace-like

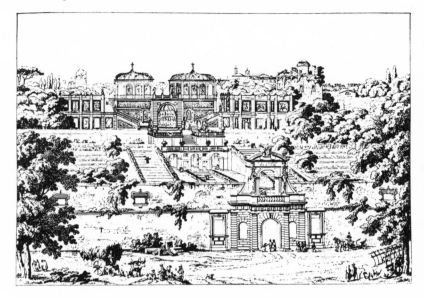

Fig. 32 The Orti Farnesiani on the slopes of the Palatine

area, at first narrow, but widening as the staircase descended, a transition to a taste for large surfaces. In the Villa Mondragone this terrace is already quite large,[9] half-way to the wide outlook that would at that time still have seemed too wild and unconfined.

The rear terrace. The area behind the house offered the same contrast to the approach as the front façade did to the rear one. Here one was at ease and unobserved; restraint could be relaxed. Where the front terrace was square, the rear was circular, the motif of the *teatro* derived from that of Bramante (pl. 19) in the Belvedere courtyard in the Vatican. The best of these is at the *Villa Aldobrandini* (pl. 21),

which is richly furnished with niches, fountains and statues.[10] Round the entrance planting was subject to strict regimentation. Flower-beds in front were bordered by hedges up to head height, dense and enclosing; behind, the hedges were lower and the whole lay-out free and open.

Even beyond the immediate surroundings of the villa, the entire garden was dominated by a tectonic spirit. This in itself was no novelty: in Renaissance gardens natural motifs – such as trees and water and rough ground – had all been stylised, and the different parts of the garden had been divided from each other and given a tectonic setting. But these tectonic elements had had no structural connection with each other; there had been no unifying composition.

It was this unification which was the achievement of the baroque. In the Renaissance natural terrain was accepted without any attempt to impose order on it. The Villa Madama, a typical Renaissance garden, was designed under the direction of Raphael, and three plans for it are extant, one from Raphael's own hand, a second by Francesco da Sangallo and a third by Antonio da Sangallo, the two last both drawn also for Raphael.[11] The plans illustrate several phases of development. Raphael's design shows three adjacent motifs. In the centre is a circular garden; to one side of it and at a lower level is a kind of hippodrome; to the other, also lower down, a square garden. The three levels are connected by large flights of steps, but the whole lay-out lacks unity, both in itself and in relation to the house. Because it must follow the lie of the land at the foot of the Palatine, it is at an angle to the house. In a small valley behind it there was to have been a nymphaeum with water (including a large pool) as the main motif.[12] In the designs of the two Sangallo, essentially similar, the composition would have been somewhat closer knit: to the right of the house three terraces, one above the other, following the line of the hill, would have made for a greater unity with the

house. But the terraces were widely different in character; there was no question of a regular plan.

The baroque garden did not follow the terrain; it subordinated it to a unified scheme. The whole design was dominated by one all-embracing view, and the position and effect of every detail was determined by its relation to the whole. Thus the axis of the house was followed through in the garden; the pavilions or casinos were set on this, not scattered haphazardly or relegated to a corner. Everything was symmetrically arranged. The earliest composition attempted in this manner was the Villa d'Este, but it suffers from the axis of the palace and of the main walk, which is carried through the garden, not coinciding with that of the waterfalls.

The gardens of the Villa Lante and Caprarola offer two perfect solutions of the problem of symmetry. In the Villa Lante[13] there is a square enclosed area in front of the two houses, and the slope is treated as a single whole. The principal means to this is a waterfall that transforms itself into a complex of cascades, the terrain on both sides being varied but always symmetrical. The four stages of the garden are all differently conceived and connected by a variety of flights of steps. At the top a level terrace has a fountain in the centre and two small pavilions corresponding to the two lower palaces. The same unity appears in all subsequent garden designs.

It must seem strange that landscape, the most painterly of all subjects, should be most rigorously subordinated to architectural rules in the period of the 'painterly' style. But the paradox is only superficial: the baroque stylised nature in order to give it a greater poise and dignity, and this was in answer to the demands of the age. But the natural park did not entirely disappear under this schematic treatment; the formless and unconfined were drawn into the composition – a fact which accounts for the development of

the landscape painting of Poussin and Gaspar Dughet.

The park was assimilated into the architectonic lay-out in two ways. Turning by stages into a wilderness it came nearer to unformed, untamed nature, and the view of the landscape beyond became in turn an essential part of the composition, with avenues laid out expressly to end in a distant view. In other words, non-structural, formless and unbounded elements were absorbed as the necessary complement to form and structure. This is a conception of which the Renaissance was quite ignorant. The garden architecture of the baroque worked with more space and larger motifs than the Renaissance. The wide space, the 'spazioso', was its ideal. Vincenzio Giustiniani, himself the architect of a garden in Bassano, wrote in a letter that the design must be made in a generous spirit, 'con animo grande'.[14] 'Le piazze, i teatri, e vicoli siano più lunghi e spaziosi che si può.' Everything had to be as large as possible, and crowding or cramping avoided at all costs: 'e sopra tutto non pecchino di stretto o angusto.' Petty floral effects, 'lavori minuti di erbette e fiori', were forbidden; only large motifs were to be used: 'ornamenti pui sodi, cioe de' boschi grandi, che abbian o del salvatico, de' boschi d'alberi, che mantengono sempre foglie' . . . In the park elegance and colour had to give way to large-scale effects, and the flower-beds and botanical or medicinal plants, once scattered all over the garden,[15] were now banished to an isolated enclosure called the '*giardino segreto*', a special ornamental garden close to the house. This was an open sunny space, lucidly and geometrically laid out with paved paths, clearly defined flowerbeds and low privet hedges.[16] The Villa Madama had the first garden of this kind,[17] a 'giardino' in the strict sense, with additional '*horticini*' in one corner where such small plants as medicinal herbs were probably grown. An orange grove on the second terrace corresponded to this, while the third terrace was reserved for firs and chestnut trees.[18]

In the garden of the Belvedere the *giardino secreto* lies in a sunken hollow immediately behind the palace, while in later gardens it is completely hidden from view by surrounding walls, or placed on high terraces on both sides of the house; alternatively it was hidden in a corner where it did not interfere with the symmetrical lay-out of the whole.

In the Villa Mondragone the *giardino* lies in a closed courtyard beside the palace, with two heavily rusticated loggias facing each other.

Eventually the *giardino* returned, in the form of a sunken terrace, to become the main feature of the villa; in the Villa Doria and the Villa Albani, it was given a magnificent decor of statues, niches, steps and fountains. This is the second phase of the baroque style.

By its separation from the garden the park was given over to the large motifs; clumps of trees, avenues and great circuses were now its component elements, and all single flower-beds and small paths were excluded.

The town garden steered a middle course between the park and the *giardino segreto*. Being limited in space, and affected by inevitable obstacles like roads, it had no particular character or development of its own.

The baroque spirit was expressed not only in overwhelming spaces, but in the closed and severe treatment of its masses. The Renaissance garden was light and open: according to Alberti the villa was to be surrounded by flowering meadows and a sunny open landscape: 'Nolo spectetur uspiam aliquid, quod tristiore offendat umbra.' ['Let nothing be within view that can offend the eye with a melancholy shade.'][19] In the Roman baroque garden there were few such open spaces. Dense masses of dark foliage replaced the sunny grove and the bright meadow (except in Tuscan villas such as Castello), and bright colours changed to dark masses.

In this garden the single tree as such had no place. It was only effective as one of a large number, so that we find huge clumps of evergreen oaks, crowded closely together and surrounded by the high, clipped laurel hedges that form such a characteristic feature of the Italian villa. The contrast between form and formlessness was purposely underlined by cutting the hedges into strictly geometric shapes and by placing stiff herms at the corners, while the greenery behind these pushed out above in huge bushy masses as if about to burst its frame.

The early Renaissance was uninterested in trees with heavy foliage, either single or in heaped compositions, and Alberti banished the oak to the orchard. It demanded spacious, well-ordered groups, in Alberti's words: 'Arborum ordines ad lineam et intervallis comparibus et angulis correspondentibus ponentur, ut aiuut ad quincuncem.' ['Trees ought to be planted in rows exactly even (in the form of the quincunx), and answering one another exactly upon straight lines.'][20]

The plans for the Villa Madama show that this kind of lay-out had been planned for the terraces to the left of the house. The trees may however have been of a more unusual kind; conifers and chestnuts would have probably already formed a massive group called a 'salvatico'. From this time open flower-beds become scarcer, yielding ground to the thicket that spread further and further in all directions until it covered the whole garden. As well as oaks, dark firs and cypresses were used; for hedges, mulberry and cypress as well as laurel. Alberti had even suggested roses.[21]

The second function of the arrangement of trees was *to mark out the paths and piazzas*. The different varieties were to be used discreetly: cypresses, for instance, formed a monumental approach to the villa and should be kept for this purpose. The Villa Mondragone, the Villa Mattei and the Boboli Gardens in Florence all have wonderful cypress

avenues. In the Villa d'Este cypresses were used only to surround the main features of the garden, the circus in the centre of the lowest level and the curved branching staircase half-way up to the house. Single cypresses are never seen. Elms and oaks were also used for vaults of foliage over the avenues. It is not always clear in the descriptions, especially in the early period, whether the phrase 'viale coperto' indicated that the trees were actually trained,[22] but the path with a leafy roof was something new in itself. Sometimes antique statues were also used to line these wooded avenues, not singly but always in groups: the Villa Mattei is the best example. If there were not enough figures to fill all the spaces between the trees, it was better to have none at all.

The wood took the form of a wilderness closing off the garden and was crossed by numerous paths. The renowned open *pineta* or pine grove – such as the one in the garden of the Villa Doria – was not one of the motifs of early baroque art. It belongs to the second period, when, in this respect as in others, a movement towards lighter and looser forms began.

Water, like vegetation, was disposed in masses in the baroque garden; there were no more small trickles or transparent fountains, only deep, opaque, cascading masses. Alberti had talked only of 'aquulae, ... fontes et rivuli limpidissimi', clear pools, fountains and streams.[23] It is symptomatic that, once the taste for massive forms was established, we no longer find in landscape painting the clear, transparent streams and pools of the pictures of the earlier Renaissance. One remembers that crystal clear water was Winckelmann's favourite symbol for the antique.

A baroque villa without water is almost unthinkable;[24] it was the period's favourite element. The baroque was fond of rustling effects, both rustling foliage and rushing streams of water. No expense was spared to obtain water in sufficient

quantity and power.[25] Perhaps this was first suggested by the River Teverone which was near enough to the Villa d'Este to supply it with unlimited quantities of water. Tivoli still had many slight and purely decorative elements that did not occur later (pl. 33); the long wall with its innumerable little fountains can hardly be compared with that of the Villa Conti at Frascati and its twenty-two great niches.

The forms which water assumed in the baroque garden were the fountain (*fontana*), the cascade (*cascata*), and the pool.

The fountain. Fountains were isolated or placed in a wallniche. The treatment could be either tectonic or rustic, in extreme cases with a naturalistic rock formation. The combination of these two contrasting types produced four main types of fountain.

1. The free-standing fountain. The elements of the freestanding tectonic fountain are the lower basin, the stem, the upper bowl and the water-spout rising out of it. Occasionally there is a second bowl. The basin was at first an angular structure, later round or oval with curved ends. Its profile is bulbous, turning strongly inwards at the bottom. A few shallow steps connect it to the ground. Vignola's famous Fontana della Rocca, in Viterbo, still had the angular form, and so did Giacomo della Porta's fountain in the Piazza Campitelli. The one with the most beautiful outline must have been that by Domenico Fontana once in the Piazza del Popolo (pl. 31), which derived from Giacomo della Porta's fountain in front of the Pantheon. Where the upper bowl of the Renaissance fountain was flat and had a sharp rim, it now became deep, the rim curled over, so that the water splashed over evenly on all sides. The baroque was uninterested in single jets of water; the water had to overflow formlessly in all directions. For a similar reason it was forced out in bunches of jets. From the magnificent fountain in the Piazza S. Pietro the water is pushed out

through a broad, mushroom-shaped spout and then falls back into it, and when such an arrangement was not feasible, the stream was at least a full one. It was the falling rather than the rising of the water that was the important element. The fountain became broader and lower until eventually the bowl was no longer above ground-level, but a sunken pool.

Fig. 33 The 'Aqua Paola'

2. *The wall-fountain* is not usually found in isolation, but in groups of three or five niches. The most famous fountains of this type were the Aqua Felice (1587)[26] and the Aqua Paola (1612), by Domenico and Giovanni Fontana respectively. Both are set in large round niches with a heavy attic and finial. In the Aqua Paola the system is extended by adding two

smaller niches at the corners of the three main ones (fig. 33). In both fountains the shape of the bowls was originally different, with a single round basin to each niche;[27] the large lower basins in front were added later, possibly in imitation of the Fontana di Trevi.

The main type of naturalistic fountain was the '*fontana rustica*', built up of boulders and rock. It was, as one would expect, created for the country villa, where it was known long before Bernini dared to erect his monumental rustic fountain in the Piazza Navona.

The '*fontana rustica*' reached the end of its development at an early date, with Maderna's fountains in the Vatican gardens, and it is easy to understand how it could turn into the grotto. The grandest, the *fontana dello scoglio* or rock fountain, consisted of a huge heap of rocks, with grottoes and a pool in front, out of which water squirted and bubbled in all directions. A similar type was the stalactite cave, or *stanzone della pioggia*, which varied in its use of structural forms. Blocks of *tufa* and sea-shells were known already to Alberti, and there is a description of such a structure, dating from 1538, by Annibale Caro,[28] who had a taste for such things. The whole is dark and awe inspiring – echo effects are described – 'dun orrore che tiene insieme del ritirato e del venerando' ['of a dreadfulness at once mysterious and awesome.'] Vasari included a few pointers in the Introduction to the *Lives*,[29] but he was still thinking in terms of small motifs.

3. The cascade. In a garden laid out on the side of a hill a cascade would form the centre-piece. It was not an undisciplined stream of water, but highly stylised, with individual large and massive effects of running and falling, and it became more formal as it approached the house. The finest was the long *cascata* at the Villa Aldobrandini. The water appears high up at the top in an untamed, natural setting as a *fontanone rustico*; it falls straight down between

hemispherical boulders, gathers, falls again over a high wall into a pool, disappears and reappears, alternates again between falling and gathering in a pool. Now the structure becomes more definite: the water falls over a wavy, sharply inclined ramp, and finally the cascade appears as the centre-piece of the *teatro* behind the villa (pl. 21).

Perhaps the most perfect cascade was that at the Villa Conti. It consists of only one effect, but this is large, powerful, and noisy. It runs over four bulging prominences, each larger than the last and each containing a bowl with curled brim, glides over a ramp with a scale pattern,[30] and falls into the next bowl. There are no small details, no spiral columns for the water to play around, no shells on balustrades pouring water into each other in little cascades.

4. *The pond.* The rectangular fish pond or bathing-pool was already known in the Renaissance, and it usually formed part of a fairly formal composition. In the Villa Madama it is set against the lateral terrace, close to the house, while in the Villa d'Este it is composed together with the flower-beds. Later ponds were usually round or oval and had a fountain in the centre. They were always deep, for the bottom must not be seen. The Villa Doria has the first naturalistic lake, set in the less formal outskirts of the park with a small island in the centre, but the naturalism is confined to banks of rusticated stones; the lake is regular in shape and the island occupies its exact centre.

Water, finally, was used for purposes that have little to do with the formal ideas of the baroque. These were the musical devices so much admired at the time, and the practical jokes indulged in by the owner of the villa.

The baroque loved loud noises, and nearly all large water-displays were connected to sound-effects. The most famous of these, which were in the *teatro* of the Villa Aldobrandini, were described by Friedrich Keyssler in the account of his travels:[31] a lion fighting with a lioness, who

imitates most naturalistically with squirting water the snarling of an angry cat. The central jet makes a noise like shells exploding, and a centaur blows a horn so loudly that the noise can be heard miles away. Watery jokes played a large role in contemporary illustrations and no garden is represented without a few figures taken unawares by jets of water. The visitor had to take great care before he sat down, opened a gate or went up a flight of stairs. In this respect the Villa Conti seems to have been particularly dangerous.[32]

It is important to realise that the style of these parks was designed for large and splendid companies of people. There was no licence to relax in these surroundings and the severely stylised garden encouraged stateliness and dignity. One would not take a casual walk along those paths: they were to be traversed in stately processions, with a large train, ladies, horses and carriages, rather in the manner of the *fêtes galantes* to be founded in paintings of a later period.

The modern garden of the north, where nature is left as nearly as possible untouched, was the direct opposite of the Italian park. I do not mean the pseudo-naturalistic English or Chinese gardens with their rustic bridges, huts of straw, or artificial ruins, but those that catered for the taste of a Rousseau with a yearning for nature, an elegiac sentimentality. The longing for a return to a pure nature untouched by man is an ideal as foreign to Italian garden architecture as it was to the rustic poetry of a Tasso or a Guarini. The Italian has no urge to communicate with nature, and yet his spirit is liberal, for the park of the Italian villa is open to everybody. This spirit is variously expressed in the inscriptions collected by Keyssler. The most beautiful, the gardener's edict from the Villa Borghese, may find a place here as a modest tailpiece:

Villae Burghesiae Pincianae
Custos haec edico :
Quisquis es, si liber,

Legum compedes ne hic timeas,
Ito quo voles, carpito quae voles,
 Abito quando voles.
Exteris magis haec parantur quam hero,
 In aureo Seculo, ubi cuncta aurea
 Temporum securitas fecit,
Ferreas leges praefigere herus vetat:
 Sit hic amico pro lege honesta voluntas.
 Verum si quis dolo malo
 Lubens sciens
 Aureas urbanitatis leges fregerit,
 caveat ni sibi
 Tesseram amicitiae subiratus villicus
 Advorsum frangat.[33]

Introduction

1. Jacob Burckhardt: *Cicerone*; first published in 1855
2. The chief sources used here include: Vasari: *Le Vite dei più eccellenti pittori, scultori ed architetti*, 2nd ed., 1568; ed. Milanesi, Florence, 1878–85; Giovanni Baglione: *Le Vite de' pittori, scultori, architetti, etc., dal 1572 fino al 1642*, Naples, 1733; Francesco Milizia: *Memorie degli architetti antichi e moderni*, Bassano, 1784. Heinrich von Geymüller: *Die ursprünglichen Entwürfe für S. Peter in Rome*, Paris and Vienna, 1875; *Ibid.: Raffaello Sanzio studiato come architetto . . .*, Milan, 1884.
3. Now in the Royal Institute of British Architects, London.
4. Destroyed, but recorded in drawings and engravings. A drawing by Parmingianino is published by Geymüller: *Raffaello . . .*, p. 57, fig. 30.
5. Michelangelo completed this building, as is well known. By raising the height of the walls for the sake of the heavily projecting cornice he totally ruined the façade because all the proportions were thereby altered.
6. Michelangelo described the staircase in a letter to Vasari in 1558 and sent a model of it to Ammannati in the next year.
7. It is already indicated on a map of Rome of that year. A roughly contemporary engraving is reproduced by Paul-Marie Letarouilly: *Édifices de Rome moderne*, Paris, 1857, Text, p. 721. The present appearance of the staircase does not incidentally reflect Michelangelo's intentions. The reclining river-gods are correctly placed but he had planned a niche for the centre which was to contain a colossal standing figure of Jupiter. The niche is now so small because of the fountain in front of it that it can only accommodate a small and ugly statue of Roma. The fountain appears in representations from before 1600.
8. Vasari: *Vite*, VII, 222: 'una salità, qual *sarà* piana'; [an ascent which *will be* gentle].
9. Vasari: *op. cit.* VII, 107; this date may be taken as correct.
10. *Ibid.*, VII, p. 694.
11. They are shown in illustrations as early as 1555.
12. The church of S. Maria degli Angeli near Assisi dating from 1569 is so fundamentally different from the Gesù that the traditional attribution to Vignola is most likely unfounded.

13. Francesco Villamena: *Alcune opere d'architettura di Vignola*, Rome, 1617.

14. Baglione, *op. cit.*, p. 76. See Gottfried Kinkel: *Mosaik zur Kunstgeschichte*, Berlin, 1876, p. 46, for genealogical table of the Milanese Porta (the family of Gulielmo), in which our Giacomo finds no place. That later authors from Milizia onwards try to make him a Milanese may be due to the fact that there actually was a Milanese architect by the name of Giovan Jacomo della Porta (Vasari: *Vite*, VII, p. 544.). Even Vasari seems to have been confused about the family history of the della Porta for he makes him Guilelmo's uncle, instead of his father. Later we shall encounter him again.

15. [This façade is now attributed to Giudetto Giudetti. T.N.].

16. *Capriccioso* (from *capro*, he-goat) means wayward, peculiar. Vasari uses it frequently, and as a term of high praise for the art of Michelangelo: 'ricoprendo con vaghi e capricciosi ornamenti (*ornamenti* means more than decoration) i difetti della natura.' (*Introduction*, I, p. 136). *Ibid.*, VI, p. 299, *Life of Mosca*: 'Non e possibile veder più belli e capricciosi altari. . . .' *Ibid.*, VII, p. 105, in the *life of Vignola*: 'Bella e capricciose fantasie'. Later it occurs in the collection of 'ornamenti capricciosi' of Montani and Soria (Rome, 1625).

The same goes for *bizzarro* (Vasari, I, p. 136 and elsewhere), and *stravagante*: see Vasari, VII, p. 260, *Life of Michelangelo*, referring to the Porta Pia: 'stravagante e bellissimo'. Giovanni Paolo Lomazzo, in his *Trattato dell'arte* (Milan, 1585), uses exactly the same terminology.

17. I cannot give a more precise date for its adoption there. Milizia, writing in 1784, was not yet acquainted with it.

18. Vasari, *op. cit.*, V, p. 448: 'Quelle reliquie di edifizi, che noi come *cosa santa* onoriamo e come sole bellissime c'ingegniamo d'imitare.' Elsewhere Vasari makes very different judgments; see below.

19. Giacomo Barozzi, called Il Vignola: *Regola delli cinque ordini d'architettura*, Rome, 1563.

20. 'Mi è piaciuto di continuo intorno questa prattica degli ornamenti vederne il parere di quanti scrittori ho possuto, e quelli comparandoli fra lor stessi e con l'opre antiche, vedere di trarne una regola.'

21. Vincenzo Scamozzi: *Idea cell'architettura universale*, Venice, 1615.

22. *Op. cit.*, I, Lib. I, Ch. xxii, p. 64.

23. As an example he takes a door (from the neighbourhood of Foligno) whose arch reaches right into the pediment. This is open at the bottom and only the supporting half-columns carry fragments of entablatures; cf. the windows originally planned by Sangallo for the second storey of the Palazzo Farnese. Serlio also knew this little monument and what he says about it is significant: 'E ancora che paja cosa *licentiosa*, perchè l'arco rompe il corso dell'architrave e del fregio, nondimeno non mi dispiacque la inventione. La cosa è molto *grata alla vista*.' ['And also it seems a licentious thing, because the arch breaks through the moulding of the architrave and the

frieze; nevertheless the invention does not displease me. It is very pleasing to the eye.'] Serlio, *Libri d'Architettura*, Bk. III, p. 74.

24. *Vita di Michelangelo*; VII, p. 193. Cf. Ascanio Condivi: *Vita di Michelangelo*, Ch. lii: 'cosa inusitata e nuova, non ubbligata a maniera o legge alcuna antica over moderna' [speaking of the project for the façade of a palace for Pope Julius III T.N.]; 'mostrando, l'architettura non esser stata così dalli passati assolutamente trattata, che non sia luogo à nuova inventione non men vaga e men bella.' ['A new and unusual work, not dependent on any manner or rule, ancient or modern. It shows that architecture has not been treated of so completely by those of the past that there is no room for new inventions that are no less beautiful or charming.']

25. Vasari says of the Porta S. Spirito, a building of already pronounced baroque character: '. . . con tanta *magnificenza*, che pareggia le cose antiche.' [' So magnificent, that it equals the works of the ancients.'] *Vita di Antonio da Sangallo*, v, p. 465.

26. Vasari: *Vite*, VII, p. 263.

27. E.g. with reference to the cornice of the Palazzo Farnese, (VII, p. 223) and the Medici chapel in S. Lorenzo (VII, p. 193.) At the time some of the nobility opposed it in vain.

Part I, Chapter I

1. Again it is a question of a difference in degree: the earlier style was not flat in the sense of a pure line drawing.

2. The Italians, however, never went to the same lengths as the Dutch with their love of uncertain, flickering effects. They remained faithful to their instinct for sculptural effects even here; the light effects are large and simple, and the movement is expressed in terms of moving figures rather than the indefinite atmospheric movement of which Rembrandt was so great a master.

3. The oblique position is indispensable for the painterly representation of architectural façades. For the motif of overlapping in this context, see below.

4. Flat patterns which are so complicated that the underlying design is unrecognisable are capable of having a completely painterly effect. We need only think of arabic patterns in which a restless flickering results in an impression of perpetual movement. With this in mind it is interesting to look at the design of the floors in the frescoes of Raphael's Stanze; whereas that in the Disputa is completely still, in the Heliodorus it is jerky and restless. This is a new method of enhancing the effect of a painting.

5. This development is perhaps most clearly visible in the treatment of hair. [Wölfflin elaborated his ideas on the painterly style in *Die Klassische Kunst*, first published in 1899, of which an English translation by Peter and Linda Murray appeared in London in 1952, and in

163

Kunstgeschichtliche Grundbegriffe, published in 1915, and published in English as *Principles of Art History; the problem of style in later art*, trans. by M. D. Hottinger, London, 1932. T.N.]

Part I, Chapter II

1. 'Neque qui spectent satis diu contemplatos ducant se quod iterum atque iterum spectarint atque admirentur: ni iterato etiam inter abeundum respectent.' Leo Battista Alberti: *Op. cit.*, Bk. IX, Ch. IX. ['. . . after the most careful and even repeated views, (the beholder) will not be able to depart without once more turning back to take another look.' *Ten Books on Architecture*, by Leone Battista Alberti, translated into English from the Italian by James Leoni; ed. by Joseph Ryckwert, London, 1955. T.N.]

2. All the most prominent baroque artists suffered from headaches; see Milizia: *Memorie*, II, p. 173; for Borromini *ibid.*, II, p. 158. There were also cases of melancholia. [See also Rudolf and Margaret Wittkower: *Born Under Saturn, The Character and Conduct of Artists*, London, 1963, Chs. V and VI. T.N.]

3. The opposite is the 'maniera gentile'. I do not agree with Rumohr who identifies the 'maniera grande' with the 'painterly style'; 'ingrandire la maniera' unquestionably implies more.

4. Vasari: *Vite*, V, p. 469.

5. Brunelleschi's building is the central three-storey block. The two-storeyed wings, which extend the façade from 356 to 676 feet, were added in the seventeenth century, and the side projections in the eighteenth. [The Palazzo Pitti was probably begun by Luca Fancelli after 1458, on the plans and designs of Brunelleschi. T.N.]

6. '. . . il componimento e troppo sminuzzato dai risalti e dai membri che sono piccoli.' ['the composition is too cut up by the projections and the members, which are small.'] This criticism by Michelangelo of Antonio da Sangallo's project for the façade of St. Peter's became a common theme; Vasari: *Vite*, V., p. 467.

7. This innovation was immediately adopted in Rome. Characteristically the Renaissance form persisted much longer in northern Italy, in the work of Palladio, Sansovino, Sanmichele. The simple colonette of the early Renaissance baluster can be seen in Brunelleschi's works: the Palazzo Pitti, the cupola of the Florentine Duomo, the Pazzi chapel, etc.

8. For the articulation of church façades, see below.

9. $b:B=B:(b+B)$. [For a brief discussion of the golden section and its importance in art see: Rudolf Wittkower: *The Changing Concept of Proportion*, in 'Daedalus,' *Journal of the American Academy of Arts and Sciences*, Winter 1960, pp. 201ff. T.N.]

10. It appears as early as Alberti in S. Maria Novella in Florence and S. Andrea Mantua in Mantua, with the ratio $b:B=1:2$.

11. The Renaissance type is illustrated by Serlio, *op. cit.*, Bk. IV, fol. 149.

Part I, Chapter III

1. It is interesting to observe, for instance in the representation of trees, an approach to form in landscape painting which is definitely comparable; broad, copious masses of foliage replace the small, slender trees of the Renaissance, and the heavy, juicy leaves of the fig may almost be called baroque. This type of foliage is at its most characteristic in the paintings of Annibale Carracci. Also it is the dark, heavy colours that were now used for preference; paintings became heavier, as it were.

2. Vasari: *Vite*, VII, p. 224, 'Con *nuovo modo* di sesto in forma di mezzo ovato fece condurre le volte . . .' ['he had the vaults made in a new way in the shape of semi-ovoids.']

3. The motif of the giant pilaster, with columns in the basement, occurs again in a pure form in the eighteenth century with A. Galilei's façade of S. Giovanni in Laterano.

4. Vasari: *Vite*, VII, p. 397.
Giovanni Bottari: *Raccolta di lettere sulla pittura, scultura ed architettura da' più celebri personaggi . . .*, Milan, 1822–25.

5. Jacob Burckhardt: *Geschichte der Renaissance in Italien*, Stuttgart, 1878 and many later editions, the first volume of *Geschichte der neueren Baukunst*, ed. by J. Burckhardt and W. Lübke.

6. Bottari, *op. cit.*, I, p. 120. In painting the same criticisms were made: Federigo Zucchari found the colours of the Bolognese too dry compared with those used in Lombardy; he said that it was necessary to 'ingrassare [fatten] il secco colorire della scuola caraccesca.' Bottari, *op. cit.*, VII, p. 513.

7. In northern Italy brick walls were left exposed for some time longer.

8. The use of continuous stone courses rather than individual blocks had begun already with Raphael. The faceted rustication of the Gesù Nuovo in Naples (1600), which spreads over the whole façade, is quite contrary to the baroque spirit. This typical baroque motif resulted in a form which resembled the human ear: for this reason in southern Bavaria the name given to the baroque style was the 'Orwaschlstil', or earlobe style.

9. Vasari: *Vite*, I, Introduction, p. 123: 'più d'ogni altro maestro ha nobilitato questa pietra Michel Agnolo Buonarotti nell'ornamento del cortile di casa Farnese.'

10. The abrupt projection of the Florentine pitched roof was extremely offensive to the eye of a Roman.

11. Referring also to the other examples, it should be mentioned that the momentum of the movement also played a part. A surface abutting in a curve therefore has more movement than a completely flat one, and so forth. This will be discussed below in a different connection.

12. Coupled half-columns and pilasters were used already in the Renaissance.

13. Cf. Serlio: *op. cit.*, fol. 119. It is possible that these forms are part of Peruzzi's alterations.

14. Most interestingly, Bernini in his statues produces an effect of duplication in certain bones, such as the shin.

Part I, Chapter IV

1. Unfortunately the mania for ornament in a later period so disfigured many interiors that the effect of contrast has been destroyed.

2. If the corresponding motifs of the lower and upper storeys are compared, it will be seen that, for instance, the window-like recess above the principal niche on the lower is oblong and has large extended consoles ('ears'), while that on the upper storey is square, with an inscribed circle; this is the most perfect way conceivable of bringing the composition to rest.

3. The fact that the bays have alternately two and three windows or niches each increases this restlessness, since there is a dichotomy within the surface-filling itself.

4. In Raphael's project for the façade of St. Peter's the intercolumnation is animated, but not yet rhythmic.

5. Moreover the staircase was meant to be of wood, not stone.

6. Peruzzi's Palazzo Massimi alle Colonne cannot be included, as its shape was evidently dictated by the curve of the street rather than by any aesthetic considerations.

7. Vasari did not miss the opportunity of pointing out this new motif: *Vita di Sangallo;* v, p. 458: 'fece Antonio la facciata della zecca vecchia con bellissima grazia in quello angolo girato in tondo, che è tenuto *cosa difficile e miraculosa.*' ['Antonio executed the façade of the Zecca Vecchia (old Mint) of Rome, a work of great beauty and grace, . . . making a rounded corner, which is held to be a difficult and even miraculous thing.']

8. Curved palace façades were unknown in Rome, but not elsewhere.

9. Raphael's Madonna di Foligno, otherwise already quite painterly in conception, still has a circular glory.

10. Giacomo della Porta provided the dioscuri at the head of the stairs with rectilinear pedestals (1583) [now changed to ovals; T.N.].

11. *Op. cit.*, Bk. v, fol. 204.

12. Alberti presented the manuscript to Pope Nicholas V in 1452; the first printed edition appeared in Florence in 1485.

13. Alberti, *op. cit.*, Bk. vi, Ch. ii.

14. Alberti: *op cit.*, Bk. ix.

15. Alberti's whole conception is independent of Vitruvius, who defines *proportio* as 'ratae partis membrorum in omni opere totiusque commodulatio'. ['Proportion consists of taking a fixed module, in each case, both for the parts of a building and for the whole.']

 M. Vitruvius Pollio: *De Architectura*, ed. Granger, London, 1931, *lib.* iii, 1, 1.

16. Cf. the conspicuous lack of proportion between the end walls of the Galleria Farnese and the paintings with which they are decorated, which look, as it were, undigested.

17. Alberti: *op. cit.*, Bk. IX, Ch. V: 'Quae si satis constant, statuisse sic possumus pulchritudinem esse quendam consensum et conspirationem partium in eo cujus sunt ad certum numerum finitionem collocationemque habitam ita ut *concinnitas* hoc *et absoluta primariaque ratio naturae* postularit.' ['. . . if what we have here laid down appears to be true, we may conclude beauty to be such a consent and agreement of the parts of a whole in which it is found, as to number, finishing and collocation, as congruity, that is to say, the principal law of nature requires.']

Part II

1. Adolf Göller: *Zur Aesthetik der Architektur*, Stuttgart, 1887; *Ibid.*: *Entstehung der Architektonischen Stilformen*, Stuttgart, 1888.

2. It appears to me that Göller's analogy with the too-often repeated melody that 'plays itself out' is misleading. This does in fact happen, but it is not easy to compare an architectural style with a melody; the comparison should be with a musical style which admits of an infinite number of forms within itself.

3. The only possible solution – one that few are prepared to attempt – would be the explanation of the new style as an inevitable reaction against the old. This would lead by Hegelian methods to the theory of a development whose motive force is antithesis. Such a hypothesis, however, hardly fits in with the actual events; it would do violence to the facts in much the same way that the history of philosophy did by attempting to clarify its concepts by abstract relationships.

4. I have dealt provisionally with this subject in my dissertation, entitled *Prolegomena zu einer Psychologie der Architektur*, Munich, 1886 (cyclostyled).

5. *Ibid.*, p. 50; cf. Gottfried Semper: *Der Stil in den technischen und tektonischen Künsten*, Munich, 1878, II, p. 5.

6. The nearest English equivalent of this word might be 'attitude to life'.

7. Note that Raphael's composition is vertical and Carracci's is horizontal.

8. The expression of emotion was for a long time excluded from Florentine art, which remained neat, unruffled and severe. In Venice a calm well-being was the dominant strain, while the Lombards favoured prettiness and elegance.

9. Anton Springer: *Raffael und Michelangelo*, 2nd ed., Leipzig, 1883, II, 2 p. 247.

10. Jacob Burckhardt: *Cicerone*.

11. The motifs of the figures of the Medici tombs are prefigured, partly even anticipated by the nudes above the Sybils on the Sistine ceiling;

cf. the figure of Twilight with the left-hand figure between the Cumaean Sybil and Isaiah. A similar mood is conveyed by the Louvre Slaves. Michelangelo's final conception of the human body was a state of total, formless collapse, and of a complete absence of will, seen in the late Pietà of the Duomo in Florence and the Rondanini Pietà in Milan.

12. Torquato Tasso: *La Gerusalemme Liberata*, 1584, Canto 1, 9.

13. [*Of dames, of knights, of armes, of loves delight,*
Of curtesies, of high attempts I speake,
Then when the Moores transported all their might
On Affrick seas the force of France to breake;
(Trans. by John Harrington.)

14. [*Arms, and the Chief I sing, whose pious hands*
Redeem'd the tomb of Christ from impious bands;
Who much in council, much in field sustain'd,
Till just success his glorious labours gain'd;
In vain the pow'rs of Hell oppos'd his course;
And Asia's arms, and Libya's mingled force;
Heav'n bless'd his standard, . . .]
(From the translation by John Hoole, London, 1763.)

15. '*O Musa, tu che di caduchi allori,*
Non circondi la fronte in Elicona,
Ma su nel Cielo infra i beati cori
Hai di stelle immortali aurea corona . . .' Canto 1, p. 2.
['*O sacred muse! who ne'er, in Ida's shade,*
With fading laurels deck'st thy radiant head!
But sit'st enthron'd with stars immortal crown'd,
Where blissful choirs their hallow'd strains resound.'
(Hoole, *op cit.*)]

16. Bojardo's poem appeared in 1494, and Berni's transcription in 1541.

17. See Ignatius Loyola's *Exercitia Spiritualia*, first published in Rome in 1548.

18. Carl Justi: *Winckelmann und seine Zeitgenossen.*, 2nd ed., Leipzig, 1898, I, p. 254.

19. Richard Wagner: *Saemmtliche Werke*, IX, p. 98 f.

20. Arthur Seidl: *Vom Musikalisch-Erhabenen.* Dissertation, Leipzig, 1887, p. 126. – August Wilhelm Ambros: *Geschichte der Musik*, Leipzig, 1880–2, IV, p. 57.

21. Alberti, *op. cit.*, Bk. IX, Ch. v: 'Quidquid enim in medium proferat, natura, id omne ex *concinnitatis* lege moderatur, neque studium est majus ullum naturae quam ut quae produxerit *absolute perfecta* sint.' ['And every production of nature herself, which are all directed by the law of congruity, nor does nature study any thing more than to make all her works absolute and perfect . . .']

22. Carl Justi, *op. cit.*, II, 364.

Part III, Chapter I

1. According to Antonio da Sangallo, it would have been rather dark: 'detta nave sarà ischurissima.' Vasari: *Vite, Commentario alla Vita di Antonio da Sangallo*, v, p. 477.

 Presumably Raphael counted on the painterly effect of contrast between the dark nave and the light crossing; cf. the similar, dark, painterly architecture of the Heliodorus fresco.

2. Generally attributed to Antonio da Sangallo. The interior is certainly by him, the façade was only completed in the pontificate of Sixtus V by Ottavio Mascherino. See Baglione, *op. cit.*, p. 94. Comparison with the latter's other works makes it seem probable that in the main he followed the design of Sangallo.

3. The Romans had effected an analogous transformation of the Greek capital, substituting the *acanthus mollis* for the *acanthus spinosa*.

4. Cf. Serlio, *op. cit.*, Bk. iii, fol. 66.

5. The façade of SS. Annunziata in Genoa is wrongly attributed to the Roman della Porta, being actually by his Milanese namesake, a fact which should suggest itself from the fundamentally different style.

6. Vasari (*Vite*, i, p. 273) says that it incorporated parts of another building; this may well have been a contributory influence. Nor did della Porta execute the building himself: cf. Baglione, *op. cit.*, p. 77: 'le porte con li due ordini della facciata furono di suo ordine e disegno.'

7. In northern Italy, however, the towers are isolated, not united with the mass. Cf. Serlio, *op. cit.*, e.g. fol. 215.

8. The related church of S. Trinità de' monti does not originate with Domenico Fontana, as is generally assumed. He is only responsible for the staircase and portal of the church. (Stated by Giovanni Giacomo Rossi in the caption to the illustration in *Nuovo teatro della fabriche di Roma moderna*, 1665, Bk. iii, unnumbered folio.)

 Ranke erroneously makes a passage from Gualterius' life of Sixtus V refer to the Spanish steps, when evidently what is meant is the staircase in front of the church itself: 'scalasque ad templum illud ab utroque portae latere commodas perpulcrasque admodum exstruxit.' Leopold von Ranke: *Die Römischen Paebste*, i, 8, p. 310.

9. The façade was probably begun by Sallustio Peruzzi and was completed by Ottaviano Mascherino. A comparison with S. Maria della Scala makes it likely that this traditional attribution is correct.

10. This motif returns in S. Carlo de' Catarinari and S. Caterina da Siena.

11. Milizia, *Memorie*, ii, p. 143.

12. The proportion 1:1·25 of the side to the main domes in S. Maria da Carignano in Genoa, by Galeazzo Alessi, is a Renaissance conception still current in northern Italy long afterwards.

13. The windows of the nave are so high that they do not let any direct light into the chapel.
14. The reason for this appears to have been not only that all available space was absorbed by the nave, but that no strong counterweight should act against the longitudinal effect.
15. It has an aisleless nave, with chapels, a dome and a choir terminating in an apse. But several features are unbaroque: the length of the nave to the cupola is 3:1 instead of a desirable bare 2:1; the conspicuous treatment of the transepts, with chapels in the side walls, and the small choir apse.
16. A friend observed that it was like a quick holding of the breath before the great chasm of the cupola.
17. Geymüller, *op. cit.*, p. 244.

Part III, Chapter II

1. Artists in general, it may be remarked, tended to become men of rank. They became members of the highest society, joined the ranks of the *cavalieri* and were used for diplomatic missions, a development which helps to explain several stylistic features.
2. This is the case in Rome; but cf. Ammannati's courtyard in the Pitti palace, and the Archbishop's palace in Milan by Tibaldi.
3. While Ammannati's Palazzo Anguillara in Florence repeats the system of the Palazzo Lardarel, it is typical that the articulation should have been omitted.
4. The ideal conception can be seen in pictorial representations; such as a painting ascribed to Poussin in the Galleria Doria, showing the Palazzo Salviati, in which this section of the building is elongated out of all proportion; this makes it look much more dignified.
5. In Vignola's buildings – e.g. the Palazzo Farnese in Piacenza – they had still been provided with their own narrow strip-moulding.
6. It is anticipated by the animated, yet measured disposition of windows on the side walls of the Palazzo Farnese.
7. According to Serlio smaller rooms were required in winter as they were more easily heated.
8. The vertical membering is suppressed even in the rusticated base. The attic cannot in its present form be ascribed to Raphael, in fact, it may be questionable whether his design included an attic at all.
9. Neither the small Palazzo Spada in the Via Capo di Ferro nor Vignola's palace on the Piazza Navona are rusticated. Giulio Romano never succeeded in solving this problem satisfactorily; proportion was not his strength.
10. There are restorations in Letarouilly, *op. cit.*, III, p. 346; and Geymüller, *op. cit.*, figs. 30 and 31, the former after a drawing by Parmigianino. These two are more in the spirit of the Renaissance than Letarouilly's; the arcade on the ground floor is more important,

and the first floor less dominating, while the cornice is given more accent.

11. Some are of uncertain authorship.

12. The Florentines retained the independent window. Only Ammannati, after his stay in Rome, attempted to introduce the new forms, but had to abandon them in the Palazzo Pitti and return to the old practice.

13. Vasari, *Vite*, VII, p. 191: '(Michelangelo) fa il modello di alcune finestre in ginocchiate per il palazzo de' Medici a quelle stanze che sono sul canto . . .'

14. Without the inner framing strip carried through to finish off the sill, as the Renaissance liked to do.

15. The increase in carriage traffic required widening of the roads, and this again could not be without important influence on the palace façade.

16. Scamozzi stipulated that the palace should have enough space to allow for a gradually unfolding view to the approaching carriages (*op. cit.*, I, 241.).

17. The arcades of the façade and the rear were walled in at a later date.

18. Vasari, *Vite*, VII, p. 224: '. . . a una occhiata il cortile, la fonte (the Farnese bull), strada Julia ed il ponte e la bellezza dell' altro giardino fino all altra porta.'

19. Vasari: *Vite*, VII, p. 108.

20. Sodoma's *Marriage of Alexander and Roxana* in the bedroom was evidently intended to make the room seem larger also; the painting is unframed except for a small balustrade at the bottom which produces a most unpleasant effect.

21. Like churches, palace interiors were darker than they had been in the Renaissance.

22. *Op. cit.*, Bk. I, p. 305.

Part III, Chapter III

1. The theoretical distinction comes as early as Alberti, *op. cit.*; for the country villa see Bk. V, Chs. xv–xvii, for the suburban villa Bk. IX, Chs. ii–iv.

2. 'Tota aedium facies atque congressio penitus sit illustris atque admodum per spicua. – *Arrideant omnia* adventu hospitis atque congratulentur.' *Ibid.*, Bk. IX. Ch. ii.
 ['I would have the front and whole body of the house perfectly well lighted, . . . Let all things smile and seem to welcome the arrival of your guests.']

3. In the north a 'salle à l'italienne', this kind of room was called.

4. Alberti, *op. cit.*, Bk. IX, Ch. ii.

5. Peruzzi's projected design for Caprarola was also a pentagon, probably deriving from the older fortress erected by Antonio da Sangallo. See Vasari, *Vite*, V, p. 451 n.

6. This is very close to Antonio da Sangallo; cf. especially the porch with the garden loggia of the Palazzo Sacchetti.

7. Serlio states explicitly that in the country everything is permissible. (*Op. cit.*, Bk. VII, p. 16).

8. The lay-out of the Villa Lante is characteristic of the Renaissance: two houses at the foot of the incline, and an entrance in the shape of a square terrace.

9. The large columns seen here and elsewhere are flues from the underground kitchens.

10. See Giovanni Battista Falda: *Li Giardini di Roma*, Rome 1683, and Domenico Barriere: *Villa Aldobrandina Tusculana*, Roma, 1647.

11. Heinrich von Geymüller first brought these to light again and recognized their importance, in his *Raffaello Sanzio studiato come architetto*. The plans are in the Uffizi in Florence.

12. Studies by Antonio da Sangallo are in the Uffizi.

13. The traditional attribution is to Vignola, and indeed the kinship with the lay-out of Caprarola is conspicuous. The villa seems to be the earlier building. The forms are meaner, more of an agglomeration; severer in that there are circles rather than ovals, etc. It has been suggested that the villa received its present aspect in 1564, while the second building, the tree plantations and the waterworks were added in 1588; but I cannot find the citation on which this evidence is based.

14. Bottari, *op. cit.*, VI, p. 117 ff.: letter to Teodoro Amideni.

15. Alberti, *op. cit.*, Bk. IX, Ch. iv: 'haerbis rarioribus et quae apud medicos in pretio sint, hortum virentem reddet.' ['. . . the gardens should be enriched with rare plants and such as are in most esteem among the physicians.']

16. Sometimes there is also a *giardino de' semplici*, or garden for medical herbs and exotic plants, as well as a variety of orchards. None of these are however included in the lay-out of the grounds, but remain apart from it.

17. This is indicated by the inscriptions in Francesco da Sangallo's plan.

18. It may be to this tripartition, also to be observed on Antonio da Sangallo's uninscribed plan, that his marginal note on another drawing, Uffizi Arch. No. 1054, refers: 'la villa sia partita i tre parti ī urbana rustica fruttuaria.' To the author's knowledge, however, neither the appellation 'urbano' for the decorative garden, nor 'rustico' for the garden with massive vegetation ever became current terms.

19. Alberti, *op. cit.*, Bk. IX, Ch. ii: 'prati spatia circum florida et campus perque apricus.' ['(nor should there be any want of) . . . flowery meads (and) open champains.'].

20. i.e. like five spots on a dice. Alberti, *op. cit.*, Bk. IX, Ch. iv.

21. Cf. Madonnas in rose gardens, which later no longer occur.

22. Bottari, *op. cit.*, VI, p. 119: 'Ed anco nel giardino siano viali coperti, i quali sono assai in uso in Francia, ove si dicono *allées*.'

23. *Op. cit.*, Bk. IX, Ch. iv, '. . . praerupent aquulae praeter spem locis complusculis.' ['. . . with five springs of water bursting out in different places where least expected.']
24. Bottari, *op. cit.*, VI, p. 120.
25. Rome was also famous for its many fountains. So Scamozzi, *op. cit.*, I, p. 343: 'sopra tutto Roma, ove non è piazza nè campo nè strada principale che non abbia una o due bellissime fontane.'
26. The idea of Moses striking water from the rock as a fountain figure had already been conceived by Michelangelo. See Vasari, *Vite*, VII, p. 58.
27. Or so it would seem from the illustrations in Falda, *op. cit.*, 1691.
28. Bottari, *op. cit.*, v. p. 271 ff.
29. Vasari, *Vite*, I, Introduction, Ch. v, p. 140ff.
30. This pattern is very common; cf. Maderna's fountain in front of St. Peter's.
31. Friedrich Keyssler: *Neueste Reisen . . .*, 1751, I, p. 696.
32. Cf. Keyssler, *op. cit.*, I, p. 686. Serlio (*op. cit.*, Bk. III, p. 121) quotes an example on a grand scale at Poggio Reale near Naples. When the king was in good humour, he drenched the ladies and gentlemen of the company with water at a single touch: 'e cosi ad un tratto, quando pareva al re, faceva rimanere quel luogo asciutto nè vi mancavano vestimenti diversi per rivestirsi. . . . O delitie Italiane,' he adds, 'come per la discordia vostra siete estinte.' ['and so in a moment, when he wished, the king made that place dry again, nor was there any lack of diverse garments for changing into . . . O Italian pleasures, how are you extinguished by your present discord.']
33. ['I, *Guardian of the Villa Borghese*
 On the Pincio, declare:
 Whoever you may be, if free,
 Fear here no regulations.
 Go where you wish, pluck what you wish,
 And stay indeed as long as you wish.
 This garden is intended more for strangers than for owner.
 In a golden age, when peaceful times
 Have made all things seem golden,
 The owner declines to post up rules:
 Let your good will be here the friendly law.
 Yet, if someone deceitfully,
 Wilfully, knowingly
 Breaks the golden laws of courtesy,
 Let him beware lest a displeased gardener
 Withdraws the token of his friendship.']

ACKNOWLEDGEMENTS AND SOURCES

I am grateful to the following for providing the line drawings: Benno Schwabe & Co., the Courtauld Institute. The half-tones were provided by the following: the National Gallery (11); Gab. Fot. Nat. Rome (4, 17); Leonard von Matt (8); the Mansell Collection (Alinari, 1, 2, 3, 10, 13, 16, 22; Anderson 9, 12, 14, 15, 23, 24, 29, 30); the Courtauld Institute (19, 21, 25, 27, 28, 31, 32, 33); F. R. Kersting (7, 26); Oscar Savio (20); Gab. Fot. Florence (18). The following are the more important sources for the line-drawings and half-tones; Letarouilly (figs. 10, 14, 23, 28, 29, 32, 33); Falda (figs. 12, 13, 17, 25, 26; pls. 21, 31, 32); Sandrart (figs. 20, 22); Duperac (fig. 21; pl. 25); Serlio (fig. 24); F. Lafreri (fig. 27); Rossi (fig. 28); Baltard (pls. 27, 28); Piranesi (pl. 33). The remaining figs. are taken from the German text.

SELECT BIBLIOGRAPHY

1. ALBERTI, LEONE BATTISTA: *Ten Books on Architecture;* translated by James Leoni, ed. by Joseph Ryckwert, London, 1955.
 The first Renaissance treatise on architecture, finished in 1452 and first published in 1485 in Florence.
2. VASARI, GIORGIO: *Lives* Dent (Everyman), 1963.
 Biographical account of the artists of the Renaissance. First appeared in 1550; second edition 1568. Only complete ed. is by G. du C. St. Vere, 10 vols., London, Medici Society, 1912–1915; best selection is by George Bull, London, Penguin, 1965.
3. BURCKHARDT, JACOB: *Der Cicerone;* first published 1855. In print.
 This is still one of the most revealing general guides to Italian art; no English translation exists.
4. PEVSNER, NIKOLAUS: *Outline of European Architecture.* London, Penguin; latest edition, 1963; best ed. is illustrated Jubilee ed., 1960.
 An introduction to the main styles and periods of European architecture.
5. WITTKOWER, RUDOLF: *Architectural Principles of the Age of Humanism,* London, 3d ed. 1962.
 An examination of the theories and principles underlying Renaissance architecture, as shown in the works mainly of Alberti and Palladio.
6. LOWRY, BATES: *Renaissance Architecture.* ('The great ages of world architecture.') London, 1963.
 A concise essay on the underlying principles of Renaissance architecture, with many plates.
7. WITTKOWER, RUDOLF: *Art and Architecture in Italy, 1600–1750.* Penguin History of Art. London, 1958; 3d revised ed. 1973.
 Detailed history of baroque art in Italy.
8. MILLON, HENRY A.: *Baroque and Rococo Architecture.* ('The great ages of world architecture.') London, 1963.
 A concise essay on the development of baroque and rococo.
9. HEYDENREICH, L. H., and W. LOTZ: *Architecture in Italy, 1400–1600.* Penguin History of Art. London, 1974.
10. ACKERMAN, JAMES S.: *The Architecture of Michelangelo.* London, 1961.
 A monograph on Michelangelo's career and importance as an architect, fully documented in text and plates.
11. MURRAY, PETER: *The Architecture of the Italian Renaissance,* 2d revised ed. London, Thames and Hudson, 1969.

INDEX